LOST
MACKINAC
ISLAND

LOST
MACKINAC ISLAND

KELLY PUCCI

THE
History
PRESS

Published by The History Press
Charleston, SC
www.historypress.com

Copyright © 2023 by Kelly Pucci

Cover: The New Mackinac Hotel. *Courtesy of Mackinac State Historic Parks Collections, G.1998.28.*

First published 2023

Manufactured in the United States

ISBN 9781467149181

Library of Congress Control Number: 2022949521

Dedicated to members of the Mackinac Island Community, past and present.

CONTENTS

Acknowledgements 9
Introduction 11

Lost Buildings 13
Deadly Diseases 30
Lost Schools 42
Lost Entertainment 62
Lost Industry and Commerce 69
Lost Laws 79
Lost Vessels 97
Lost Nature 117

Bibliography 123
About the Author 128

ACKNOWLEDGEMENTS

Thank you to the Mackinac State Historic Parks guides who answered questions with enthusiasm, including April Nieman, who arranged for us to fire the cannon at Fort Mackinac, and Andrew Flynn, who guided us through the process on a cold autumn morning.

We appreciate the hard work of Mackinac State Historic Parks Collections registrar Brian Jaeschke, whose encyclopedic knowledge provided us with exactly the right information.

Thanks also to Mackinac State Historic Parks director emeritus Phil Porter for his e-mails.

We are much obliged to City Clerk Danielle Leach for her encouragement.

We are grateful to librarian Anne St. Onge, who allowed us to linger in her beautiful library as we read the historic documents she selected for us.

Thanks also to the staff of the Colon Public Library, who retrieved dozens and dozens of relevant books from the Michigan interlibrary loan system.

Thank you to the editors of the *Town Crier* and Michilimackinac Historical Society for your informative publications.

Thank you, Leona McKeen, for setting the record straight about Bishop Baraga.

A special thanks to Larry Wright, Patricia Wright and Wayne Sapulski for sharing their knowledge of Great Lakes lightships.

And above all else, thank you John Rodrigue, acquisitions editor of The History Press, for keeping me going through the pandemic and myriad health problems. Many thanks also to my husband, Joe Pucci, for accompanying me on road trips to Mackinac Island.

INTRODUCTION

To view Mackinac Island is to view a Victorian picture-postcard come alive: wooden houses trimmed with gingerbread; tiny shops crammed to the rafters with bibelots, gewgaws and objets d'art; old-fashioned ice cream parlors and tea rooms; well-groomed soldiers; sedate churches; and horse-drawn carriages driven by uniformed coachmen and women. It almost looks too perfect to be real. But Mackinac Island is no Disneyland or open-air museum. The buildings are not reproductions—they are real, and they are really old. Currently, the island is home to five hundred or so year-round residents, who accommodate the throngs of visitors that invade their beautiful island each summer and who celebrate the return to tranquility after the last tourist departs the island.

Was it always this way, you might wonder? No. The Victorian homes and quaint shops established a century ago belie Mackinac Island's long history, much of which is lost today. Come with us on a journey through the lost history of Mackinac Island: the rich and complex history of the Anishinaabeks, who for hundreds of years camped along the island's shores and fished its clear, blue waters; the fur traders who built an economic powerhouse controlled by a wildly wealthy immigrant from Germany; the Europeans who brought Christianity and diseases to the island; the soldiers who fought bravely at Fort Mackinac and Fort Holmes; and the island's flora and fauna destroyed by nature and man's interference.

LOST BUILDINGS

LOST FORT MACKINAC BUILDINGS

Fort Mackinac is so beautifully preserved that upon seeing its bright white buildings perched atop the hill, it is easy to assume that the buildings have remained in perfect condition, showing no wear and tear over the centuries, but perhaps allowing that handicapped accessible features were added in the late twentieth century. In reality, over the course of the fort's history, much of Fort Mackinac has been lost: original buildings fell to ruin, burned to the ground or were removed or demolished. Three buildings (a barracks, a provisions storehouse and a guardhouse) dragged across the frozen straits from Fort Michilimackinac circa 1780 did not survive for long. Fort Mackinac played an important part in the history of our country, yet it suffered from lack of much-needed funds denied by faraway bureaucrats in the nation's capital who viewed Mackinac Island as "a place where [there] are the summer homes of some thirty-five families and objects of interest to the summer tourists," abandonment by troops on at least two occasions and armed conflicts and federal neglect during its twenty-year tenancy as a national park. However, thanks to the work of the knowledgeable museum curators, historians, preservationists, archivists, architects and volunteers at the Mackinac State Historic Parks and the Mackinac Associates, who maintain the fort's history and natural beauty, its future is in good hands.

Today, fourteen buildings remain, each built over a period of time beginning in 1780: the Commissary Building, Post Headquarters, Quartermaster's Storehouse, the Bathhouse, the Soldiers Barracks, the Schoolhouse or Reading Room, the Hill Quarters, the Hospital, the Officer's Stone Quarters, the Wooden Quarters, the Guardhouse and the North, East and West Blockhouses. A few of the buildings feature minimal historic furnishings, but most were repurposed as museums or other attractions for modern-day visitors. Tourists can enjoy a magnificent view from the tearoom in the Officers' Stone Quarters while enjoying a pita with hummus or a quinoa and an avocado salad prepared by the staff of the Grand Hotel and then pick up a souvenir from the Sutler's Store in the Soldiers' Barracks.

Craig P. Wilson, chief curator at the Mackinac State Historic Parks, wrote a definitive history of the fort's preservation in a booklet called *The Changing Face of Fort Mackinac*:

> *Perched on a cliff over Mackinac Island's harbor, Fort Mackinac is today preserved as an historic site. Visitors may be forgiven for assuming the fort was similarly well-maintained during its 115 years of service. In reality, Fort Mackinac was plagued by poor design, chronic, dilapidation, and governmental indifference from the moment British soldiers broke ground in 1779. Although major improvements were occasionally made, most found themselves stationed in an obsolete crumbling fort. These men included Captain William Doyle, who in 1793 begged for assistance to address "the State of universal ruin, which prevails in the Fortification, and public Buildings at this Post." The story of Fort Mackinac reflects a perpetual battle between natural decay, repair, military necessity, public service, social reforms, and government spending.*

Changes to the fort began almost immediately after it was built, beginning in 1798 with a redesign of the fort's perimeter when Major Henry Burbeck and his men removed a wooden wall and strengthened the structure with stone, giving the fort its famous triangular shape. Early in the nineteenth century, a fence that separated the village from the fort was removed to promote good relations between soldiers and civilians who resided on the island.

Lost to history is the hospital that shared space with a mess hall in the Provisions Storehouse. Soldiers demolished the building and built a new hospital in the summer of 1827. Unfortunately, the new hospital burned to the ground in October 1827, just ten days before its scheduled completion.

A new hospital was built the following year but was of poor construction, described by Lieutenant Colonel Enos Cutler as "illy constructed and injudiciously located." Cutler requested funds of $5,000 to build a new hospital. Unfortunately, the money didn't arrive until 1860, when the poorly constructed yet still standing hospital was converted for use as a warehouse.

William Whistler (the uncle of the artist James McNeil Whistler, who created the famous painting commonly known as *Whistler's Mother*) received an odd suggestion when the inspector general observed Fort Mackinac in 1834, when he was the fort's commander. The original powder magazine leaked so badly that the inspector general recommended to Whistler that no powder should be sent to the fort until construction of a new magazine. His report read in part:

> *Most of the powder and 20,000 out of 48,290 musketed cartridges on hand, are damaged from the dampness of the magazine. Let not therefore any further supplies of either be furnished until the magazine be rendered secure against all changes of weather, and which might be done at a small expense.…To render the magazine properly secure and dry, it will be only necessary to line it with good thick plank properly tongued and grooved and so placed as to avoid contact with the walls and ceiling of the building which are at all times damp and very frequently quite wet and dripping.*

Withholding gunpowder from a military fort was perhaps not the best solution to the problem.

Because fires continued to plague the fort, a system of stone cisterns and a reservoir beneath the barracks were installed in 1853. Despite these measures, a fire destroyed the barracks in 1855. The *Buffalo Democracy* reported that an unusual method of fire prevention may have contributed to the barracks' demise:

> *The officer in command thought it would be a good idea, as water was not easily to be obtained, to fire cannon shot into the buildings in such a way as to cut off the communication of the fire with parts not yet kindled. Accordingly, the field pieces were ranged on the parade, loaded with shot, and the cannonade was commenced. The shot all told, and perhaps would have fulfilled the expectations of the ingenious officer, had not a slight error in the practice been discovered too late. To the great astonishment of all beholders, the shot exploded in the buildings, throwing the burning fragments in every direction, and spreading the disaster beyond the hope of*

remedy. The guns had been loaded with shells instead of solid shot! The result was most unfortunate, for the wooden buildings in the garrison were chiefly destroyed.

The fire-damaged bakery was rebuilt only to be destroyed in 1913 along with a carpenter's shop, powder magazine and coal shed. According to Craig Wilson, "A board of inquiry determined that the proximity of the bakery, barracks, and other buildings, combined with poorly constructed cisterns and the lack of a reliable water pump, contributed to the fire's destructiveness."

Lost to history are the granary, blacksmith shop and stables, replaced by Marquette Park. Fortunately, also lost are the water closets and smelly privies that one post surgeon described as "vile and intolerable" and were the source of deadly diseases, as they were "in immediate proximity to the kitchen." These were replaced by flush toilets in 1889.

Dr. Beaumont treated typhoid victims with opium he grew in his medicinal garden on Mackinac Island. *From* Early Mackinac *by Meade C. Williams.*

Lost is the five-acre vegetable garden below the fort where soldiers grew crops to supplement their meager rations. Today's gardens at the fort are not original and certainly do not include the opium grown in Dr. William Beaumont's medicinal garden. During the War of 1812, Dr. Beaumont successfully treated two hundred typhoid patients with his own mixture of opium and turpentine, and for years he continued to prescribe opium to soldiers at Fort Mackinac. The *Life and Letters of Dr. William Beaumont* recounts Dr. Beaumont's plea to the War Department to keep the garden, his description of the garden, its purpose and his fight against the federal Indian agent's attempt to purloin half the land:

What most particularly claims my attention, and in my humble opinion requires your interposing influence, is the deprivation it will be to the sick and invalids—that class of soldiers most essentially benefited by garden privileges—and the detriment it will be to the Medical Dept., inasmuch as it will take the whole of the Garden of this garrison, which has been many years occupied and improved for the particular use, and without which the

sick must suffer for want to many vegetable comforts not otherwise to be obtained on this Island....[The garden] *is handsomely laid out into squares, walks, alleys, etc., with bowers of biennial and perennial plants, fruit trees, etc., beside the germs of other medicinal plants and ornamental flowers, the seed of which I brought from the interior and have been at considerable trouble and expense to introduce into this garden for the future use of the sick....I have likewise introduced the seed and am endeavoring to cultivate the Papavar Somniferum* [opium] *and the Marrubium Vulgari* [horehound], *which are very efficacious in many diseases, and more especially the obstinate pulmonary complaints of this country.*

Lost to history is the fort's artillery, with the exception of an iron twelve-pound gun that served aboard a ship during the War of 1812, now on exhibit at the fort. The British removed artillery from the fort in 1796 when it was turned over to the United States. During the War of 1812, British troops brought their own weapons to the poorly fortified fort, and at the conclusion of the war, they once again removed their artillery. Lieutenant Colonel George Croghan, who fought at the Battle of Mackinac Island in 1814, returned to Fort Mackinac as inspector general of the U.S. Army and ordered the removal of much of the fort's remaining artillery. The practice of firing ceremonial cannons on a daily basis to recognize historical figures and special events ended in 1887 when the parsimonious War Department stopped funding the practice. Public outcry forced the War Department to repeal the prohibition the following year, whereupon the sound of cannons was again heard on the island. When Fort Mackinac was established as a national park in 1875, the War Department sent a few obsolete pieces of equipment to the park, which remained on display until they were melted down in a World War II scrap drive. Not all islanders agreed to melting weapons for scrap. Some Mackinac citizens who felt strongly that the island could reach its wartime quota without sacrificing historic fort artifacts made their objections known to the *Lansing State Journal.* W.F. Doyle stated that islanders were "willing to give up household effects and personal belongings which contain metal if the state will withhold disposing of these historic reminders of battles won in previous American wars." Nonetheless, the destruction of cannons continued. Tourists who pay for the privilege to fire the cannon atop the gun platform, 150 feet above the shore, may be surprised to know that it is a reproduction.

LOST FORT HOLMES

Lost is the original wooden fort. Built by the British in 1814 as Fort George to honor King George III, it was abandoned in 1817 and returned to the United States, which christened it Fort Holmes after American Major Andrew Hunter Holmes, second in command to Croghan; Holmes died of wounds suffered in an attempt to retake the fort from the British in 1814. An ambitious plan by Major Charles Gratiot to expand the fort and rebuild it of stone, "an abundant commodity on Mackinac Island," did not come to fruition. The federal government turned its eye to building Fort Dearborn and could not justify Gratiot's plan to spend nearly $100,000 for labor plus the purchase of 300,000 bricks, 100,000 shingles and 100,000 feet of planks.

Fort Holmes closed in the winter of 1817. Without proper care, the fort began deteriorating, yet nineteenth-century tourists visited the site for its contribution to American history. The *Barre Daily Times* of Vermont recommended Fort Holmes "chiefly because it represents the scientific work of the military engineers of those early days." Casual visits to the site increased as newspapers and magazines recommended a visit to Fort Holmes, if not for its historic significance then for the stunning views of the island from the site, the highest point on Mackinac Island. A wooden tower constructed in 1886 afforded tourists an even better view of the surrounding islands. After climbing the tower, tourists who wanted to purchase a bit of history stopped at a small souvenir stand before departing for the carriage ride back into town. Yet an excursion to the site could be dangerous. Newspapers reported on the dangers of climbing the tower. The *Detroit Free Press* published an article about a bride who fell from the tower in 1906:

> *Bride Killed by Fall. Sad End of Honeymoon at Mackinac Island. Mrs. Benjamin A. Frankle fell from the observatory at Fort Holmes this morning and died at 3 p.m. from her injuries. She was on her honeymoon having been married last Wednesday. Her husband is very prominent in Utica, being connected with the trolley company. She was formerly Miss Katherine Demil of Herkimer, New York.*

Wood from the original blockhouse was removed from the site and repurposed to build a stable downtown. When the blockhouse was rebuilt in 1907, the wood found its way back to Fort Homes. This structure burned

down in 1933. The *Herald Palladium* attributed the fire to "a cigarette tossed carelessly on the heavy floors of the old blockhouse…within half an hour the Fort was only a pile of burning logs."

As part of President Franklin Roosevelt's New Deal, the Works Progress Administration reconstructed the fort in 1936. The *Detroit Free Press* reported that the government allocated a budget of $25,000 for materials and the wages of twenty-six men. The project is described thusly on the WPA website:

> [Work] *began in the summer of 1936, when the Works Progress Administration rebuilt Fort Holmes, using an 1817 engineer's detailed drawing and elevation of the original redoubt. The federal agency, operating with a workforce encamped on the northern side of the Island at the site of the current solid waste transfer station, raised a new blockhouse, re-dug the ditch, piled up soil for a new embankment, and lined the outward walls of the embankment with cedar logs to rebuild the palisade.*

The WPA structure began to deteriorate, and in the 1960s, the rotted structure was removed, leaving only the fort's front gate. In 2015, the Mackinac Historic State Parks raised $200,000 in private donations along with $250,000 appropriated by the State of Michigan to complete reconstruction of the fort to appear as it did in 1817.

LOST BUILDINGS DOWNTOWN

Mackinac's downtown shopping area, crammed with old buildings skillfully restored and brought up to code, belies its humbler origins, when downtown consisted of a few basic services—a steam laundry, a post office, a general store and a drugstore. Over the years, the area has grown, but many of the old buildings have been lost.

The British street plan of 1780 remains basically the same along the shore of Haldimand Bay, the main entrance point onto the island, with Market Street and Main Street (formerly Huron Street) running parallel to the shore and with shorter streets and lanes connecting the two.

Rows of "rickety, primitive buildings"—described by visitors to Mackinac Island in 1835 in *Historic Mackinac: The Historical, Picturesque and Legendary Features of the Mackinac Country* and described by photographer Reinhard

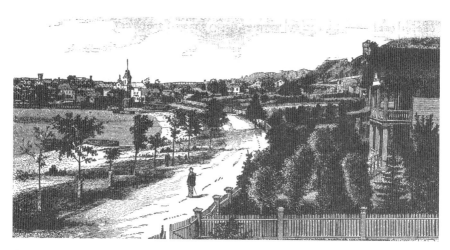

Gone are simple paths downtown, replaced by paved streets and sidewalks. *From* The Annals of Fort Mackinac *by Dwight H. Kelton.*

Wernigk in 1856 as "mostly low, dark, log structures of antique Canadian style, their yards enclosed by palisade fences"—have been demolished through the years. In 1846, William Cullen Bryant reported viewing "roofs and walls of red-cedar bark confined by horizontal strips of wood, a kind of architecture between the wigwam and the settler's cabin."

Among these was the Lasley House, a hotel/boardinghouse built in 1824 that geologist Joseph LeConte described in 1844 as "a mere tumble-down shanty of rough unpainted boards apparently in the last stages of dilapidation." Visitors had no trouble finding the Lasley House, as the proprietors kept tame bears chained to the front door. A British visitor wrote about his experiences at the Lasley House in *A Merry Briton in Pioneer Wisconsin*:

> *I was directed to the gate of the tavern, where they took in lodgers; entered the yard and found two bears tightly chained near the door….My request for a bed was treated with disdain by a fat frowsy old woman, while a stupid old boor, named Monsieur Lasley pointed to a corner house, and signified I could get lodgings in it. This proved a stupid jest.*

The New Mackinac Hotel was lost in 1938, when the city removed the derelict but once elegant three-story Italianate structure from the site that now holds public restrooms and a ferry ticket office.

In 1836, Harriet Martineau gave this description of the lost houses:

> *The houses of the old French village are shabby looking, dusky and roofed with bar. There are some neat yellow houses, with red shutters, which have a foreign air, with their porches and flights of steps. The better houses stand on the first of the three terraces which are distinctly marked. Behind them are swelling green knolls, before them gardens sloping down to the narrow slip of white beach, so that the grass seems to grow almost into the clear rippling waves. The gardens were rich with mountain ash, roses, stocks, currant bushes, springing corn, and a great variety of kitchen vegetables.*

A few extant buildings, such as the McGulpin House and the Biddle House, have lost original architectural details and no longer serve their original purpose. The McGulpin House—so named for William McGulpin, a baker for the American Fur Company, and his family, who occupied the home in the 1820s—is now a museum. This example of the *Piece-Sur-Piece a Queue de Ronde* style, in which logs were laid horizontally and attached at the ends with dove-tailed notches, is indicative of structures built in the 1780s. According

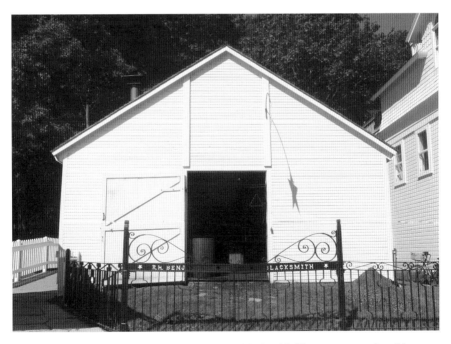

In the 1970s, the contents of the 1880 Benjamin Blacksmith Shop were moved to this reconstructed building near the Biddle House. *Author's collection.*

to the current owner of the McGulpin House, Mackinac State Historic Parks, the home may have been part of the mainland Michilimackinac community (in present-day Mackinaw City, located across the Straits of Mackinac) before it was moved to the island after 1780, and "it may be one of the oldest private residences in Michigan." Evidence shows that the McGulpin House may have placed on the west end of Market in 1781 and then moved to the area behind St. Anne's Church before it was moved to Market and Fort in 1982, each time losing some of the original structure. McGulpin made changes, such as constructing additions, to accommodate the growing family. The west portion was lost to history, and the house appears as it did in the 1820s, when the McGulpin family lived in it.

In the 1970s, the contents of the 1880 Benjamin Blacksmith Shop were moved to a reconstructed building near the Biddle House. The Biddle House was named for the Biddle family, who purchased the property from Dr. Mitchell in 1817. Only the west portion of the current structure is original; the east portion was added when the Biddles occupied the house. Built in the *Piece-Sur-Piece a Queue de Ronde* style, similar to the McGulpin House, the structure lost its original appearance when the Biddles covered the logs with clapboard.

Across the street from the Biddle House stood the Mitchell House, built in 1790 by Dr. David Mitchell, a Scottish surgeon who served at Fort Michilimackinac. Members of the Mitchell family often spent evenings playing whist with the Biddle family. Curiously, Dr. Mitchell fled Mackinac Island for Drummond Island and left his wife, Elizabeth—who was part French, Ottawa and Ojibwe—to run the family's fur trading business and farm on Mackinac, while raising the couple's thirteen children. A description of life in the house appeared in 1898 in the book *Reminiscences of Early Days on Mackinac Island* by Elizabeth Therese Fisher Baird:

> One interesting and wealthy family was that of Dr. David Mitchell, which consisted of his wife (of mixed blood), and a number of sons and daughters. The daughters, at the time now mentioned, had returned from Europe, where they had received the education which at that day was given young ladies. The sons were sent to Montreal for their education. This family were, of course, all British subjects. When the island was ceded to the United States, Dr. Mitchell would not remain there but followed the troops to Drummond's Island, where he made himself a home and where the remainder of his days were spent. His wife retained her old home at Mackinac, with the daughters and two sons. Mrs. Mitchell and her sons continued in the fur trade and added much to an already large fortune, for the trade made all rich. The mother and

Left: The original structure consisted only of a portion of the current building. The Biddle family added the eastern portion and covered the logs with clapboard. *Library of Congress, Historic American Buildings Survey.*

Below: The Mitchell House stood on Market Street across from the Biddle House. *Michigan State Historic Parks Collection.*

daughters would, in turn, visit Dr. Mitchell during the summer, but would not take the risk of a winter's visit. Two of the sons, however, remained with their father. It was the largest dwelling-house ever erected on the island. It is two stories high, with a high attic, this having dormer windows. The grounds surrounding it were considered large, running through from one street to another. The three daughters were handsome, attractive, and entertaining ladies. Winter being long and dull, these young ladies would invite a lady friend or two to spend it with them.

The Mitchell House was demolished in the early twentieth century to make way for a dance hall known as Dewey Hall. The property is now a vacant lot next to Cindy's Riding Stable (formerly Chicago Riding Stable). Nearby stands St. Anne's Church, which has been altered over the years. The original church, built on land at Main and Church donated by Madame La Framboise and described by Father Mazzuchelli as "a little wooden church erected by the piety of the faithful," was enlarged to include a rectory, new sanctuary and sacristy following a series of religious debates with Reverend William Ferry of the Mission School that renewed interest in Catholicism. That building was demolished in 1873.

The McNally Cottage, built by Irish immigrants in 1889 as a single-family home and converted into a bed-and-breakfast, fell into disrepair and was

A dance hall once stood in this vacant lot next to Cindy's Riding Stable (formerly Chicago Riding Stable). *Author's collection.*

demolished in 2011. In 2013, the modern Bicycle Street Inn & Suites and Waterfront Collection replaced the McNally Cottage at 7416 Main Street. A guest at the McNally Cottage B&B was visited in 2000 by the midnight ghost of Shamus McNally, who lived in the house until 1904, according to the *Detroit Free Press*:

> *She* [a guest recovering from an illness] *thought she was alone. But then she felt a soft hand on her shoulder…she turned to see a wizened, little old man standing behind her. Shamus spoke to her in a voice as soft as his touch. "Everything will be alright."*

No ghosts appeared when the building was demolished; however, bones found buried underneath the house were determined to be human, possibly the ancestors of the Sault Ste. Marie Tribe of Chippewa Indians. Brian Leigh Dunnigan, author of a book about the history of Mackinac Island, posits that the remains may be from the Catholic cemetery that closed in 1851. Among those buried in the church cemetery were Anishinaabek members of the St. Anne congregation. While demolition work was paused, the Sault Ste. Marie Tribe of Chippewa Indians received the bones for reburial, including three intact human skeletons found on the site.

In 2013, the Mulcrone Building, which housed a meat market and liquor store, was demolished, as the local building department deemed it unstable. It stood on the site for more than one hundred years.

For more than a century, Mackinac Island has lost buildings to fires, mostly recently in March 2022 when flames engulfed the Crow's Nest Cottage on the East Bluff near the fort. On February 1, 1887, newspapers across the country reported on a devastating fire on Mackinac Island. The headline from the *Nashville Banner* shouted, "Guests of the Mackinac House Make a Narrow Escape."

The following was reported by the *Evening Times* of Clay Center Kansas:

> *At Mackinac Island last night, while the mercury was thirty degrees below zero, a fire broke out in Truscott's saloon. The flames spread rapidly, and in a few minutes the Carson house, Mackinac house, Dominick Murray's general store, Siegfried Highstone's general store and W.P. Preston's saloon were a mass of flames. There was no fire protection at the island. Nothing was saved. The guests at the Mackinac house barely escaped with their lives. Loss $60,000; no insurance.*

On the evening of October 15, 1987, flames rose above downtown Mackinac as a fierce fire raged through downtown, fanned by eighteen-mile-per-hour gusts of wind off the lake, destroying the Davis Building, a landmark since 1897, and damaging nearby structures. According to the *Detroit Free Press*, "The village was only minutes from devastation, a loss that easily could have risen into the millions." Shepler and Arnold ferries carried crews and equipment to the island within forty-five minutes after the blaze was reported. Firefighters from Mackinac Island, St. Ignace, the U.S. Coast Guard and Mackinaw City fought the blaze for more than six hours. Fortunately, a $2 million water and sewer system (ten years in the planning stage) consisting of two water reservoirs, the largest of which held millions of gallons, was completed in the spring of 1987. Dan Musser of the Grand Hotel told the newspaper that "under the old system, we would have pumped the reservoir dry within twenty minutes." As firefighters fought the blaze on Main Street, workers at the Grand Hotel stood watch at the windows to warn of any embers that might reach the hotel roof. Before the night was over, the Davis Building was lost and Ryba's Fudge shop suffered some damage. (Trayser's Trading Post now occupies the site of the Davis Building.) In 1989, an entire block on Main Street had to be evacuated as a fire raged in the LaSalle Building during the early morning hours of September 9, killing two summer workers, a waitress from the Iroquois Hotel and a carriage driver. The fire destroyed the two-story, nearly one-hundred-year-old LaSalle Building and damaged several other buildings on Main Street. Businesses lost or damaged in the two fires include the Big Store, Betty's Gifts, Memory Lane, Ryba's Fudge, Everybody's Little Mexico, the Leather Corral, Birches Gift Shop and Kilwin's Candy. Prior tenants in the LaSalle Building's long history included the Temple Theatre, a silent film palace; the U.S. Post Office; and Western Union. In 1991, the Lilac Tree Hotel was built on the site of the lost LaSalle Building.

The Haunted Theatre opened in 1974 in a building constructed by Charles Caskey, architect of the Grand Hotel. Several businesses that occupied the building prior to the Haunted Theatre are lost to history. From 1885 to 1895, it housed a roller rink; a dance hall replaced the roller rink in 1907, and a silent movie theater replaced the dance hall. Finally, the building was refurbished as the Haunted Theatre.

Property near the Haunted Theatre has experienced many losses. The site was occupied by the Biddle Warehouse, built in the 1820s; it was lost in 1875 by the construction of the Palmer House, an elegant hotel named in honor of Chicago's Palmer House. That building fell into disrepair and was destroyed

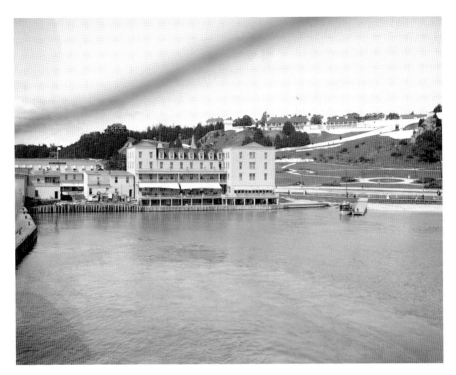

The Chippewa Hotel as it appeared in 1902. The Pink Pony opened here in 1956. The hotel underwent an extensive renovation in 1995. *Library of Congress, det4a18539//hdl.loc.gov/loc.pnp/det.4a18539.*

in 1920. The property remained vacant for more than four decades until a small restaurant was built in 1966. In 2002, the building housing JoAnn's Fudge Shop, and Nephew's of Mackinac was torn down to make way for the Main Street Inn and Suites. The Chippewa Hotel, sandwiched between Main Street and the waterfront, did not originally feature the popular Pink Pony restaurant.

Two signs on either side of the entrance to the building at 7358 Market Street identify it as a courthouse: a small oak sign constructed as part of President Franklin Roosevelt's New Deal onto which are carved the words "Built in 1839, The Michilimackinac County Court House," and a larger sign that reads "City of Mackinac Island Courthouse and Police." However, the signs are misleading. The police department is located next door at 7374 Market Street, and Mackinac Island has not had a county courthouse since 1982, when operations were moved to St. Ignace. The building located at 7358 Market Street is primarily the City of Mackinac Island's city hall, where City Clerk Danielle M. Leach is responsible for, among other duties,

the administration of licenses and permits, ranging from one dollar for a tourist bicycle license, twenty-five dollars for a drone permit and thousands of dollars for construction permits.

Lost is the Michilimackinac County courthouse, the site of a landmark case. In its heyday as a county courthouse, the little building was the site of the famous *People v. Pond* case. Ultimately decided in 1860 by the Michigan Supreme Court as *Pond v. People*, the lawsuit recognizes that a man's home is his castle. Although the source of the tension between Augustus Pond and his neighbor is muddled, the conflict came to a violent head when Mr. Plant, accompanied by fifteen to twenty men, assaulted Mr. Pond, who, though injured, was able to flee the scene. Plant and his gang—which included Isaac Blanchard Jr., the six-foot-seven, 240-pound son of a Mackinac Island judge—sought out Mr. Pond at his home but were turned away by Mrs. Pond, who claimed that her husband was not at home. The men continued to look for Pond on his property; not finding him, they decided to assault a hired hand named Dennis Cull, whom they found hiding in an outbuilding. Mr. Pond came to Dennis Cull's defense, armed with a shotgun. He yelled, "Leave, or I'll shoot." The men continued their rampage, and Pond shot to death Isaac Blanchard Jr. Mr. Pond turned himself in and was brought to the courthouse on Mackinac Island for trial. He was convicted of manslaughter and sentenced to ten years' hard labor at the Jackson State Prison.

Pond appealed his conviction to the Michigan Supreme Court, cited as *August Pond v. The People*, from whose opinion was noted:

> *The trial court should have considered the net-house* [a small structure for storing fishing equipment] *as part of Pond's home, for, "It is a very common thing in the newer parts of the country…to have two or more small buildings, with one or two rooms in each, instead of a large building divided into apartments."*

Thus, the court extended the common-law rule that "a man's home is his castle" to frontier circumstances and ordinary citizens. The Michigan Supreme Court granted August Pond a new trial, but unfortunately, he passed away before the trial commenced. The court went on to say that Pond had performed a public service, not a crime:

> *The rules which make it excusable or justifiable to destroy* [life] *under some circumstances, are really meant to insure its general protection.…They are designed to prevent reckless and wicked men from assailing peaceable*

Although it is no longer the county courthouse, this little building was the site of the often-cited landmark case *People v. Pond*. Ultimately decided in 1860 by the Michigan Supreme Court as *Pond v. People*, the lawsuit recognizes the legal principle that a man's home is his castle. *Author's collection.*

> *members of society. It is held to be the duty of every man who sees a felony attempted by violence, to prevent it if possible....* [Citizens have] *the right and duty to aid in preserving the peace.*

In 2008, the *Michigan Bar Journal* devoted an article to an examination of errors in the lower court case, saying that the "trial court [incorrectly] held that a man could not use deadly force to defend himself against a 'mere trespass'; rather, he had a 'duty to retreat' to avoid using force. Pond's net-house [the building in which the hired hand was found] was not his home; nor did the assault on Cull justify the killing. This legal decision continues to be cited across the nation, mostly famous by attorney Clarence Darrow in 1925.

Many buildings on Mackinac Island have been lost, demolished by nature and by man. (According to a National Public Radio interview, "between 1970 and 2000, more than 100 buildings were torn down.") Fortunately, members of the Historic District Commission meet regularly to review proposed demolitions and renovations of buildings within the historic district.

DEADLY DISEASES

For more than two centuries, soldiers, visitors and residents have promoted Mackinac as a healthy location. Horace Mann claimed that the Mackinac's air was sent from Eden. Fanny Corbusier, wife of post surgeon Dr. William Corbusier, claimed that her Uncle George was cured of rheumatism during a visit to Mackinac in the summer of 1882. A high-ranking officer stationed at Fort Mackinac told a visitor to the island that "the island is so healthy [that] people who want to die must go somewhere else." Ironically, shortly thereafter the officer died and was buried in the post cemetery.

Dr. Daniel Drake, president of the Medical College of Ohio, remarked on the general good health of soldiers stationed at Fort Mackinac and its "serene waves lapping the island's shores" and declared Mackinac "Queen of the Isles" and "a delightful hot weather asylum." In his book *Old and New Mackinac with Copious Extracts from Marquette, Hennepin, La Houtan, Cadillac, Alexander Henry and others*, Reverend J.A. Van Fleet advised, "No better place can be found for sickly chlorotic girls [who suffer from an iron deficiency that causes a greenish tint to the skin] and puny boys; worn out men and woman, whether from overworked brain of muscle" and "bowel complaints seldom prevail." "Those cases of consumption which are not far advanced are often greatly benefitted." Post surgeon Francis LeBarron proclaimed, "No one dies but from casualties or old age" and that "the uninterrupted current of air which constantly passes over the island…dispels all noxious vapours which arise." Despite the absence of "noxious vapours," Dr. LeBarron's private practice flourished, as he treated the venereal diseases of fur traders.

Even the American Medical Association spoke of the healthy state of affairs on Mackinac Island, positing in an 1894 article of the *Journal of the American Medical Association* that physicians who had been stationed at Fort Mackinac would become rusty from lack of patients to treat: "[A]fter four years of such service most medical officers would be required a course at some metropolitan hospital before assuming medical and surgical responsibilities at a live military post." Citing the island's good weather and the absence of disease as well as good food at the fort, the article continued:

> *There were large post gardens which furnished a plentiful supply of vegetables, fresh fish were abundant and milk, butter and eggs by no means scarce, so the garrison fared better than most of the troops in the service of the United States. The climate was moderate on account of the insular position, the summer heat rarely above 90 degrees F. and the winter temperature seldom much below freezing. The high ground north of the post was a protection against cold north winds. Spring was cold, wet and disagreeable, but the other seasons were pleasant.* [Good] *Health was the normal condition of the garrison. Life must have been very pleasant at Fort Mackinac for a lazy man or a philosopher.*

Yet these glowing accounts belie more than a century of serious and often fatal illnesses that afflicted the people of Mackinac Island. These diseases included cholera, diphtheria, dysentery, enteritis, enterocolitis, grippe (influenza), pleurisy, pneumonia, puerperal fever, smallpox, tuberculosis, typhoid, typhoid pneumonia and whooping cough. Many of these diseases (though often rare today and seldom fatal) can be treated with antibiotics and other modern medical miracles, but in the nineteenth century, there was much misinformation, plenty of superstition and few cures. Mackinac Islanders came face to face with deadly diseases compounded by infection from unsterilized medical instruments held in unwashed hands, misdiagnoses and ineffective or harmful medications.

When cholera arrived on Mackinac Island in 1832, residents read terrifying and inaccurate reports from around the territory. Nativists, who were both anti-Catholic and anti-immigrant, blamed poor immigrants arriving from Ireland by way of Canada and Detroit as the source of the deadly disease. Some Michiganders resorted to violence against suspected carriers. Armed men in Pontiac accosted travelers from Detroit, including a physician on his way to treat cholera victims. The *Democratic Free Press* reported that frightened

residents of Ypsilanti, wary of contagion, attempted to prevent the delivery of tainted mail:

> *At Ypsilanti such were the fear of the people from the supposed contagious nature of the cholera, and such their determination to enforce an entire non-intercourse with this city, that the mail stage was fired upon because the driver insisted upon doing his duty. A fine horse was killed, and the driver himself narrowly escaped.*

Mackinac residents who bought Detroit newspapers read detailed descriptions of cholera's painful symptoms:

> *Diarrhea: the evacuations at the commencement, of a dark brown or blackish hue gradually becoming less and less feculent, until they assume the appearance of dirty water…cramps, most frequently of the toes, twitching in the abdomen, with giddiness and sickness occasionally accompanying it.*

Although it is unlikely that Mackinac residents were able to lay their hands on scientific magazines, a contemporaneous account in *Scientist Magazine* described in gruesome detail a description of symptoms suffered by cholera patients, including violent cramps, "along with dehydration so rapid and severe that their skin was rendered a deathly blue. Many died within hours of the first symptoms."

Eliza Chappell, a teacher at the Mission School, described in her diary how cholera and fear attacked Mackinac Island in 1832:

> *July 7th. Mackinac is now greatly perplexed. Fear and alarm take hold of many.…Our schools are all closed, and fear takes hold on many…July 8th. This is indeed a time of consternation on our small island.…Faces gather blackness and fear takes hold of the fearless.*

In her book *A Child of the Sea and Life Among the Mormons*, Elizabeth Whitney Williams recalled, "[I]t was late in August. Cholera was raging at Mackinac Island. Fifty-two deaths had occurred there."

The authors of *A Treatise on Asiatic Cholera* described how a steamer filled with infected soldiers stopped at Mackinac Island en route to Chicago:

> *A large number of deserters from the camp [Fort Gratiot] are reported to have died from cholera in the surrounding country, many on the roadside.*

July 8th, cholera appeared among the troops from Fort Niagara; the same day two men who had been employed to communicate with the steamer Henry Clay died of the disease in the city of Detroit, and the authorities of that city have become alarmed, demanded the removal of the troops, who were accordingly ordered to the camp before Fort Gratiot. The steamship Sheldon Thompson *being free from the disease, on the 6th of July proceeded on the journey and arrived at Fort Mackinaw. On the evening of the 7th, cholera having developed among the voyage, four cases were sent to hospital. All proved fatal. July 8th, no other cases of cholera occurring, the* Thompson *proceeded on her voyage; the next day twenty-one (21) cases of cholera occurred, and when on the night of July 10th, she reached Chicago, there had been a total of seventy-six (76) cases and nineteen (19) deaths.*

In his book *The Life and Letters of Dr. William Beaumont*, Dr. Beaumont called for calm during the epidemic: "The greater proportional numbers of death in the cholera epidemics are, in my opinion, caused more by fright and presentiment of death than from the fatal tendency of violence of the disease.… Like a snake watching and writhing for its prey, the Cholera lurks unseen through the pestiferous and malarious atmosphere, stealing upon human beings and thickly populated places, and gluts its cadaverous appetite more by the fears and dread it occasions than by its otherwise naturally fatal effects upon human life."

Today, cholera is treated with hydration and antibiotics; however, remedies available to Mackinac Islanders in the nineteenth century, though well meaning and of common practice, proved ineffective. In 1832, the City of Detroit Board of Health recommended treating cholera with a mixture of two teaspoons of absinthe (the alcoholic beverage that affected the brains of Oscar Wilde and Vincent van Gogh) added to a pint of drinking water, combining twenty-four grams of opium and a glass of wine (half doses for children), applying mustard powder over the stomach or allowing a physician to open a vein to remove a pint or more of blood. Bloodletting, a common practice, was advised by authors of *A Treatise on Asiatic Cholera*:

To mitigate the spasms and render the system more susceptible to the action of the grand remedies, mercury and opium: 20 or 30 grains of calomel [no longer a medical remedy, the substance is used to create insecticides] *with 2 grains of opium and a large mustard plaster over the stomach.…Small portions of ice chewed, and small doses of camphor*

will quiet the stomach. The calomel is to be repeated every two or three hours, till the stools become bilious; friction with rubefacients; dry heat with bags of hot sand. If the skin be moist, then hot powered chalk may be rubbed in. If the pulse becomes feeble and the skin cold, rub in two parts of strong mercurial ointment with one part of camphor and the same of red pepper. Injections of hot brandy and water in large quantities of green tea frequently repeated will prevent collapse.

It was not until 1854 that London physician John Snow identified contaminated water as the source of cholera. Improved sanitation in the United States put an end to cholera epidemics by 1900; however, a form of cholera called "winter cholera" appeared on Mackinac Island in 1908. The one hundred members who attended the 1908 convention of Association of State and National Food and Dairy Departments couldn't have found a more enjoyable site to hold their meeting than upon the palatial grounds of the Grand Hotel. They pored over pages and pages of documents, including thirty pages of proposed standards defining kumiss ("the product made by alcoholic fermentation of mare's or cow's milk"), oil of cinnamon ("a lead-free volatile oil obtained from the leaves or bark of *Cinnamomum cassia*") and types of ketchups including mushroom ketchup and walnut ketchup. Between lectures, the attendees were treated to the delicious cuisine of the Grand Hotel, and speakers refreshed their throats with pitchers of cool lake water placed on conference tables. But little did they know that the hotel's water supply was contaminated. According to *Sewage Pollution of Interstate and International Waters*, published in 1912 by the Public Health and Marine-Hospital Services of the United States:

> *In August, 1908, the annual convention of State and National Food and Dairy Departments met at Mackinac Island Most of the participants stopped at this hotel and were stricken with the form of diarrheal illness commonly called "winter cholera." An investigation showed that the water used was drawn from the Straits at a point in close proximity to the sewer outfall of the hotel and that the water supply was contaminated at this time. The hotel management after considerable discussion discontinued their intake and made connection with the city supply, which is safe.*

Cholera is no longer an issue on Mackinac Island or elsewhere in the United States.

Parents who vaccinate their school-age children with the immunization combo known as DTaP (or DTP) are probably unaware of the threat diphtheria posed to families in the nineteenth century. More than ten thousand Americans died from diphtheria in 1860, and the deadly disease returned with a vengeance in the 1880s. It arrived on Mackinac Island in July, probably transported from Chicago by a young visitor. Diphtheria cards appeared on windows warning neighbors to stay away. Newspapers across the state routinely reported the deaths of children who died from diphtheria. A family in Benton Harbor buried two children—a son, nine, and a daughter, four—within a week. In Berrien Springs, four siblings died within a week. A five-year-old Owosso girl, who seemed to have recovered from the disease, became paralyzed and died a few weeks later.

Early symptoms of the disease include swollen glands, a sore throat, weakness and a gray coating on the nose, tonsils, voice box and throat, making it very hard to breathe and swallow. Worried Mackinac parents, who feared a child's sore throat was diphtheria, may have turned to cures offered in Michigan newspapers:

> *When the symptoms are first discovered, take Spanish flies* [a sexual stimulant], *pound and mix with Venice turpentine* [a remedy used to harden horses' hooves], *spread it on a piece of soft leather cloth, and bind it on the throat, which will raise a blister, and soon remove the disease from the throat.*
>
> *If quinine is administered promptly and in full doses, it will relieve nearly every case without any other treatment….* [W]*henever it is possible to use it, with a wash of chloride of potash* [a fertilizer] *for the throat and cauterization when there is much ulceration.*

Readers from Cassopolis recommended "a wash made from red pepper and salt" and something called "Shiloh's Cure" (a widely available concoction that contained copious amounts of heroin) to provide immediate relief. Today, diphtheria is treated with antibiotics, and cases of the disease are rare in the United States.

Many grief-stricken Mackinac mothers who survived the trauma of childbirth made funeral arrangements for the children they buried Mackinac Island's post cemetery.

In *Mackinac Island's Post Cemetery*, Phil Porter wrote about the tragic deaths of the children of Fort Mackinac soldiers in an era of high infant mortality:

> *Despite all his training and expertise, post surgeon Dr. Hiram Mills could not cure the illness that took his five-month-old son J Russell on August 30, 1869.…Private John Baseler buried his three-year-old daughter Lena in a small grave near the cemetery flag staff. Baseler, a sometimes unruly soldier, was serving time in the post guardhouse when Lena was near death. Post Captain Greenleaf A Goodale, a compassionate office had lost his daughter Hattie to the childhood illness. Requested permission to parole Baseler for a few days so that he could be with Lena during her final hours.*

Lieutenant Calvin Cowles and his wife, Mary, lost three children to infant diseases, two while stationed at Fort Mackinac. Five-month-old Josiah died of enterocolitis, an inflammation of the intestines occurring in babies that is today treated with antibiotics. Four years later, Isabel Cowles died at Fort Mackinac just a few weeks before her first birthday. Calvin and Mary buried their young daughter next to Josiah in the northeast corner of the post cemetery.

The American Medical Association reported that flu epidemics in 1890 and 1892 "greatly interfered with the duties of the garrison." The poor ventilation in the barracks allowed the disease, known at the time as *la grippe*, to easily circulate among the soldiers.

In the 1800s, childbirth extinguished the lives of otherwise healthy young women. Within three days of giving birth, some women on Mackinac Island (and elsewhere) suffered from puerperal fever. Early stages of puerperal fever included headache and constipation, followed by diarrhea, making it hard to distinguish this deadly disease from minor illnesses and perplexing physicians (generally male physicians whose knowledge lay in surgery, not childbirth). Difficult respiration, a change in the color of the tongue, either to white or dark and with a furry texture, meant impending death. According to "The Attempt to Understand Puerperal Fever in the Eighteenth and Early Nineteenth Centuries: The Influence of Inflammation Theory," published in the journal of *Medical History*, physicians debated the causes of puerperal fever:

[T]he fever was a pathological condition of the blood and circulation, which might have originated in the trauma of labour or in other sources of damage to the uterus or other internal organs. It was a disorder of the blood's composition, or of the rate and force with which the blood made its way through the vessels. Thus, it was believed that the most effective treatment would involve copious bleeding of the patient.

Extensive studies of puerperal fever, a including a seventeen-year study in Michigan, cited bacteria produced by poor medical hygiene during delivery as the cause of the deadly disease. Today, improved hygiene and treatment with antibiotics have greatly reduced the rate of mortality. No doubt the deaths of many young mothers could have been prevented, including the death of Mary Elizabeth Taylor Bouchard, who died on September 16, 1878, and was buried in the Protestant Cemetery; Madeline Lasley Davenport, who died on March 18, 1891, and was buried in the Protestant Cemetery; Kathryn Kate Overall Preston, who died on February 1, 1884, and was buried in the Protestant Cemetery; and Rosa Fountain Simons, who died on December 2, 1886, and was buried in Saint Anne's Cemetery.

Andrew Blackbird recalled in his book *The History of the Ottawa and Chippewa Indians of Michigan: A Grammar of Their Language, and Personal and Family History of the Author* that smallpox disseminated throughout entire villages along the straits ("lodge after lodge was totally vacated—nothing but the dead bodies lying here and there in their lodges—entire families being swept off with the ravages of this terrible disease"). When news of the epidemic reached Mackinac Island in 1846, post surgeon Erastus Bradley Wolcott (who later gained fame as the world's first surgeon to successfully remove a kidney from a living patient) already had a stockpile of the smallpox vaccine, which he administered to every soldier stationed at Fort Mackinac. The conscientious physician trained a Catholic priest to vaccinate every civilian, thereby preventing smallpox from sweeping through Mackinac Island.

Tuberculosis and pneumonia spread throughout the population, often with deadly results. Charlotte O'Brien, the young wife of post chaplain Reverend John O'Brien, died of tuberculosis in 1855, as did Private William McCabe. Within a few years, Sergeant Lewis Perry and Private Nicholas Shorten

suffered the same fate. Fanny Dunbar Corbusier, wife of post surgeon William Henry Corbusier, wrote about several cases of tuberculosis near a neighbor's house and the preventable death of Major Sellers, who "took off his coat while in a perspiration, contracted pneumonia, and after only a short illness, died." In the winter of 1880, seventy-two-year-old Charles O'Malley, who founded the first hotel on Mackinac Island, contracted pneumonia after trekking through heavy snow. A prominent member of the community, he was buried in a ceremony attended by a large number of Pottawatomie Indians from local tribes.

No doubt Alice Hamilton was looking forward to a tranquil vacation away from the stress of her life in Chicago when she and her family arrived on Mackinac Island in the summer of 1915, unaware that an epidemic would interrupt her vacation. The University of Michigan Medical School graduate worked tirelessly as a professor of pathology at Northwestern University and served on the staff of Hull House, treating immigrants who suffered from industrial diseases caused by unsafe workplaces and becoming the friend and personal physician of famed activist Jane Addams. Surely a few weeks walking among wildflowers, breathing fresh air and eating lavish but healthy meals on Mackinac Island would allow Dr. Hamilton to return to Chicago refreshed.

An avid letter writer, Dr. Hamilton corresponded with the folks back home, extolling the beauty of Mackinac Island, with its pollution-free air, its raw nature and clear water. While vacationing on the island, Dr. Hamilton wrote frequently to Jane Addams, with whom she had spent two months in Europe advocating for peace with heads of state. However, one letter Dr. Hamilton sent to a stranger stands out from all others. In this letter, she wrote "that the drinking water used on the Island was probably beyond reproach" but that she was suspicious of milk provided at a dairy farm. Dr. Hamilton's suspicions gave impetus to the Michigan State Board of Health to conduct an intensive investigation into an outbreak of typhoid on Mackinac Island in 1915.

In the 1915 outbreak, the local health officer ordered a Widal test to measure typhoid antibodies found in the blood of an infected dairy worker, and an examination of milk produced at the dairy was conducted at a clinical laboratory. Dr. Harkin, a district medical inspector for the State of Michigan, concluded, "That the outbreak was not of epidemic form at that time and might be classified as sporadic, with no determinable source of

infection." Dubious of the claim of the dairy as a source of the infection, Dr. Harkin reported:

> *The same milk* [given] *to 30 or more consumers caused no other infection. Second, analyses by the State Board and Columbus Laboratories had given negative results; Third, of the people handling the milk at the dairy, which is in average sanitary condition, the three employees give no hint of typhoid, while the water used for washing cans, etc., is above suspicion.*

As more cases occurred, four prominent Chicago physicians, summer residents on Mackinac Island, requested further investigation. A report by the Michigan Board of Health published in 1917 did not agree with Dr. Harkin's findings:

> [The] *State Board of Health undertook a thorough investigation of the causes of a typhoid fever outbreak during the previous summer. Only about a dozen cases in all occurred at this resort, but inasmuch as the healthfulness of the place had never before been questioned it was thought necessary to follow this matter up thoroughly. The study disclosed the fact that most if not all of the patients were heavy milk drinkers. It was found that the milk furnished to these patients was all supplied by one dairy. The sanitary conditions at the dairy were not good. The outhouse used by the employees was not far from the milk house, and the milk house was unscreened. It was, therefore, evident that, should feces containing typhoid germs be deposited in this privy, the infection could easily be transmitted to the milk through the medium of flies....*
>
> *The kitchen where the milk bottles are washed was so full of flies that it was well night impossible to stay inside and ask questions concerning the washing of the utensils, and the shed in which the cans and bottles were stored was at time was open directly to the flies The crudest kind of an outside closet was only twenty feet from the open door to the shed. There was some indication of lime having been spread over the deposit of human excreta in the vault of the closet, but there was a very putrid smell from the place.*

The report admonished the dairy for its carelessness and encouraged milk producers throughout the state of Michigan to learn from mistakes made on Mackinac Island. Thanks to the summer residents from Chicago who persisted in finding the source of the typhoid outbreak, no further cases have been reported.

But 1915 was not the earliest occurrence of typhoid on Mackinac Island. Private Alvin S. Bates died of typhoid fever in 1874. In August 1890, Marie Cudahy, the youngest daughter of John Cudahy, the Chicago millionaire meatpacker, died of typhoid pneumonia at Mackinac Island. Chicago newspapers reported the sad details of the girl's funeral. From the *Inter-Ocean*:

> *The white casket that rested in the center of the room* [of the Cudahy's Chicago residence] *held all that was mortal of Marie Cudahy, the 12-year-old daughter of John Cudahy, the millionaire merchant.…The services were brief, but impressive, and were followed by a solemn high mass conducted by the Rev. Father Maguire. Blatchford Kavanagh, the* [famous] *boy soprano, sang in a most effective and feeling manner.*

Local cemetery records indicate that eighteen-year-old Private Dudley Luce Preston died from typhoid fever in 1896. In June 1889, Fort Mackinac's assistant surgeon, Dr. C.E. Woodruff, described a patient suffering from typhoid:

> *As abortive cases of typhoid fever are apocryphal, or at least rare, I have no doubt that this patient was suffering from the fever for ten days, during which he was doing duty. The case was evidently mild, with little noticeable fever. When he had any appetite, he ate the regular ration. This diet, irritating and inflaming the intestinal ulcers, caused a rise of fever to 106. After the intestinal contents had been removed by purgation, the case progressed more nearly as a mild case should. Recovery in typhoid fever when the temperature has been over 106 degrees is quite rare, and the case is in so far interesting.* [The following year, a British medical journal concluded that Dr. Woodruff's diagnosis appeared] *to have been considered as such principally by the fact of typhoid fever prevailing in the locality.*

During the winter of 1813, Dr. David Mitchell of Fort Mackinac treated patients suffering from whooping cough (also known as pleurisy or pertussis) in an "epidemic, an unheard-of occurrence on the island…[it] struck many families and brought death to several children." Dr. Corbusier and his family suffered through many health scares during his years of service as Fort Mackinac's physician. In 1883, the entire family contracted whooping cough, which Dr. Corbusier treated by spraying antiseptic in the room where the children slept. A few months later, Mrs. Corbusier wrote about her son Philip:

Phil went to the hospital garden to get some horseradish roots that he heard the men were going to dig and getting his feet wet, wore his shoes all the morning. That night he began to cough and pleurisy developed in his left side. He had to be carefully nursed, and to give us a rest Lieutenant Duggan often sat with him at night.

Phil suffered chills, rapid heart rate, fever and severe chest pains for weeks. Phil's ten-year-old brother, Harold, kept a diary in which he noted Phil's condition on an almost daily basis. Other than bed rest, quiet and the suggestion that Phil should be moved to a dry climate, we do not know what treatment young Phil received. Neither Dr. Corbusier nor brother Harold Corbusier, who himself became a doctor, could have predicted that this highly contagious, airborne bacterial disease could be prevented by a vaccine developed in Grand Rapids by two determined female scientists, Pearl Kendrick and Grace Eldering.

LOST SCHOOLS

MISSION SCHOOL

Reverend David Bacon and his wife, Alice, arrived on Mackinac Island in 1802 with plans to build an Indian settlement within the island's interior to separate Ottawa Christians from their traditional village. Although lack of funds prevented the establishment of the settlement, Reverend and Mrs. Bacon briefly operated a school on Mackinac Island.

Before he gained fame as the father of the father of Morse code—invented by his son, Samuel—geographer Jedidiah Morse toured the Northwest Territory for two years, traveling 1,500 miles on behalf the U.S. War Department, gathering information and reporting back to President Monroe his observations of Native Americans and recommending measures "for their future, social, and religious improvement…and imparting the blessings of civilization and Christianity, to these untutored heathen tribes." Jedidiah Morse traveled from Detroit aboard the steamship *Walk-in-the-Water*, arriving on Mackinac Island, where he stayed as a guest of Commander Pierce for sixteen days. During this visit, he interviewed Chippewa chiefs Kishkimmon and Shewabshes, who traveled annually from Lake Flambeau to Mackinac Island to trade. He asked the men if they would like "schools for their children, and ministers to teach them religion; to have their women taught to knit, sew, spin and weave; to make butter and cheese, and to live like white people." According to Mr. Morse, they answered, "Yes, we should like it."

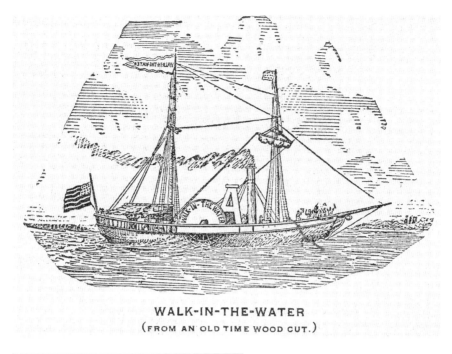

WALK-IN-THE-WATER
(FROM AN OLD TIME WOOD CUT.)

MISSION HOUSE,

MACKINAC, MICHIGAN.

E. A. FRANKS, PROPRIETOR.

This old and Favorite Hotel is delightfully
situated adjoining the

✢ *National Park* ✢

ON THE

Romantic Island of Mackinac,

Within a short distance of the Arched Rock,
Sugar Loaf, Giant's Causway, and other
natural curiosities in which this
famed Island abounds.

Good Accommodations for 200 Guests.

Above: Jedidiah Morse, who recommended the establishment of the Mission School on Mackinac Island, traveled from Detroit aboard the steamship *Walk-in-the-Water*. *From* Early Mackinac *by Meade C. Williams.*

Left: William Montague Ferry and his wife, Amanda White Ferry, lived in the Mission House. After their departure, a third story was added to the original structure. *From* The Annals of Fort Mackinac *by Dwight H. Kelton.*

Based on the recommendations of Jedidiah Morse, the Mission School was established on Mackinac in 1823 under the leadership of William Montague Ferry and his wife, Amanda White Ferry, both of Massachusetts. These evangelical missionaries were anti-Catholic (the religion of French Canadian Métis children) and held a poor view of Indians, describing them as degraded and debased and their Midewiwin religion as superstition. Nonetheless, they carried on educating the children of Mackinac Island until the Ferry family departed for Grand Haven, Michigan, to open a lumber business. One teacher, equally prejudiced against native people, complained about ungrateful students in a letter to her sister, which Keith Widder chronicled in his book, *Battle for the Soul: Metis Children Encounter Evangelical Protestants at Mackinaw Mission, 1823–1837*:

> *Many of these dear (Indian)* [Métis] *children rescued from the filth of their birthright, after being awhile with us, feel that we are doing no more than we ought—our duty—and that they are conferring favor by remaining with us! It is seldom that we receive expressions of gratitude from them.*

Parents who could not afford to pay school tuition agreed to surrender their parental rights under a Michigan territorial law "binding the children to the superintendent of the mission by legal indentures, so that they cannot be taken away [returned to their parents] till [*sic*] their education is completed." In effect, the law provided the school with unpaid laborers, some as young as six years of age. White parents didn't surrender their children. Bazil Hudon Beaulieu, John Holiday, William Aitkin and other wealthy fur traders paid the school thirty dollars annually to educate their children.

Keith Widder depicts the children's introduction to the Mission School in *Battle for the Soul*. Shortly after the children came to the school, "they surrendered themselves and their clothes to the missionaries, who scrubbed their bodies with soap and water and dressed them in new clothes." The staff believed that these children had come from the midst of "Indian degradation and wretchedness"; they hoped to wash away what they viewed as physical manifestations of the children's home environment. In doing so, they in effect washed away their identity as Métis.

Students received hand-me-down clothing from eastern households (unfashionable on Mackinac Island and unsuitable for its harsh winters), were given Christian names, ate meals of unfamiliar foods and were taught lessons in English, a language they neither read nor spoke. Teacher Elisha Loomis, who developed a Chippewa alphabet and pronunciation guide to

INDIAN WIGWAM.

Above: Teachers at the Mission School described the conditions of their students' homes as "filthy" and "debased." *From* Early Mackinac *by Meade C. Williams.*

Left: Indian agent Henry Schoolcraft managed the construction of the Indian Dormitory on Mackinac Island. *Library of Congress, cph3c09383//hdl.loc.gov/loc.pnp/cph.3c09383.*

aid teachers in learning the language of their students when he arrived at the school in 1830, met with opposition from Reverence Ferry.

Children were separated by gender in the school dormitory and dining hall and assigned "male" or "female" jobs. Boys worked in fiery forges, heating, hammering and bending metal into tools for the school and island residents; they cut and split hundreds of cords of wood to heat the school, hauled buckets of fresh water from the lake, made leather shoes to order, cleaned fish and performed countless other tasks, all without compensation for their work. Also without compensation, the girls milked cows, baked bread, swept floors, washed clothes, hand-stitched garments, made soap, assisted staff in the preparation of meals and performed countless other tasks needed to run the school. Mission School students also worked in the private shipping business owned by Reverend Ferry that carried supplies to the American Fur Company. Whether profits from the business went directly to the Ferry family or supported the school is not known; however, boys from the school provided the labor, thereby saving the shipping business wages Ferry would have paid to adults.

After visiting the Mission School, Superintendent of Indian Affairs Thomas L. McKenney wrote *Sketches of a Tour to the Lakes*, in which he expressed concern about the obstacles the students would face in the future:

> *I felt but one melancholy reflection, and that arose out of the thought, that after these children are educated, and shall have acquired the ability to advance their own happiness, and that of their posterity, there will be no homes for them to go; and no theatre for them on which they can turn their acquirements to any profitable account! Vain is all of this teaching, if those who are subjects of it are to be turned loose with no materials out of which to renew their condition.*

Illnesses spread among the students, who slept two or three to a bed in poorly ventilated rooms. In 1826, post surgeon Dr. Richard Satterlee treated several students for fever, and three years later, half of the students "were sorely afflicted with inflammation of the eyes." Sixteen students died while in the care of the Mission School.

The school day included classes in spelling, grammar, geography, history, religion and arithmetic, taught from textbooks that described native people as "savages" and "ignorant, barbarous and warlike." The teachers, who taught in English and spoke no other language and were frustrated by their students' determination to speak French or native languages, doled out corporal punishment for their students' noncompliance.

The Mission School utilized an educational system developed by English educator Joseph Lancaster. Under the Lancasterian system, older students who had gained modest proficiency in a subject, called monitors, instructed younger students. Although the system was adopted by the school's administrators, it was criticized in 1827 by Jedidiah Stevens, a Mission School teacher. In his book *Battle for the Soul*, author Keith R. Widder quoted Jedidiah Stevens's diaries:

> *When we commenced our work in the school it was conducted on the Lancasteria* [sic] *plan by monitors selected from the pupils as the most capable and trustworthy, but they were very incompetent.…I found in this way many erroneous ideas and habits had been taken up and not only this but pupils were taught words—not ideas—read in parrot fashion. I found boys who could read a whole paragraph pronouncing every word correctly without having the remotest idea of what they were reading.*

Despite presenting his ideas to Headmaster William Ferry in 1827, Jedidiah Stevens made no progress in changing the school's teaching method.

Within a few years, the need for a Mission School on Mackinac Island diminished, as fur trading declined and families moved off the island. The school struggled with leadership issues after the departure of William Ferry in 1834 and finally closed in 1837. Competition from new schools also contributed to the demise of the Mission School. Madame Magdelaine Laframboise, the daughter of French Canadian fur trader Jean Baptiste Marcotte and Marie Nekesh, taught the catechism of the Catholic Church to children at a makeshift schoolroom in her stately home (now located within the Harbour View Inn complex on Main Street) and supported the efforts of Father Samuel Mazzuchelli, a twenty-three-year-old priest from Milan, Italy, to establish a Catholic school on Mackinac Island. The school was a success when it opened in 1831; the study body consisted of twenty-six students, eight of whom had studied at the Mission School. The faculty included Martha Tanner, a former student at the Mission School who converted to Catholicism as an adult, and French Canadian Josephine Marly. In June 1832, Eliza Emily Chappell, former Mission teacher and governess to children and whose father was partner in the American Fur Company, opened an infant school (or preschool) on Mackinac Island. She wrote in her journal, "I look upon the Infant school system as designed by God to open the way for the missionary of the cross, and perfect His praise from the mouth of babes."

POST SCHOOL

In her autobiography, *Fanny Dunbar Corbusier: Recollections of Her Army Life, 1869–1908*, Fanny Dunbar Corbusier, dutiful wife of army surgeon William Henry Corbusier and mother of his five sons, chronicled her experiences at more than a dozen military bases, including in Mackinac and the Philippines. An educated woman who served as a nurse during the Civil War, she taught her boys at home if formal education was unavailable. The proud mother boasted, "Our boys were far ahead of others of their age among civilians, except in mathematics, as they were taught zoology, botany, geology, [and] ethnology by Father and knew what was going on in the world." At times, Colonel Corbusier exerted his influence with college presidents and university education departments to procure a teacher, though not always meeting with success. One potential candidate "committed suicide by drowning" before she could be interviewed, and "the fear of Indians prevented" other applicants from accepting the assignment. Thankfully, the Post School at Fort Mackinac provided the Corbusier boys with an excellent education and excellent teachers.

Mrs. Corbusier and the children arrived at Mackinac on April 23, 1882, to settle into their new home ahead of the arrival of Colonel Corbusier. The Corbusier boys spent a few months climbing rocky bluffs, searching for old military buttons and fishing for trout before meeting their teacher, Sergeant J. Fred Grant, whose patience they tested when they locked the sergeant in a room at the Post School. As their mother recalled:

> *He marched them down to the commanding officer and entered a complaint.…The march to the Adjutant's office and the formal complaint and reprimand delighted the boys, and they looked forward to such occasions as a game of some sort. They had a few minutes' drill every day, when they were treated as soldiers, and the Sergeant for a short time was a very strict disciplinarian in talk, and this the boys all liked.*

Teachers were not always as tolerant as Sergeant Grant. In 1870, an officer commanded armed troops to enter the village school and close it down because some children spent recess on military property.

The schoolhouse was built in 1879 as an institution to educate soldiers, as mandated by the U.S. Army, and unlike other posts around the country, Mackinac did not lack funds needed to supply textbooks to the somewhat reluctant group of soldiers who attended school in the evenings. Because

attendance was not compulsory and classes interfered with their regulator military duties, men were reluctant to sign up despite the school's effort to educate them in the fields of history, literature and mathematics. During the day, the military officers also taught the post's children. Compulsory education laws for children did not pass the Michigan legislature until years later; however, we can assume that the military parents who enrolled their children in the Post School made sure that their attendance was regular.

Fanny's second-oldest son, Harold, kept a diary while in school. Phil Porter, director emeritus of the Mackinac State Historic Parks, compiled the ten-year-old's musings in *A Boy at Fort Mackinac: The Diary of Harold Dunbar Corbusier, 1883–1884, 1892* and added background information about the Corbusier family. Thankfully, to preserve its authenticity, Mr. Porter did not correct young Harold's spelling or grammar: "The diary is presented as Harold left it, complete with the spelling and grammatical errors expected of a ten-year-old boy."

Young Harold's diary entries give the reader a firsthand look at everyday life as schoolboy on the island in the 1800s. He studied "spelling, reading, geography, history, arithmetic, and writing" under the direction of Private Anderson Crawford, who replaced Mr. Grant:

[March 3, 1883]
There are not many horses in the village now Most of the people use dogs instead of horses. They hall [sic] *a very big load. Four dogs are the most I have seen halling* [sic].

[March 14, 1883]
People are getting in wood from Boisblanc very fast, as they fear the ice will soon brake up.

[October 31, 1883]
It is All Hallowes [sic] *eve we going to dive for apples but there were none in town so we had to dive for potatoes.*

[March 17, 1884]
St Patric [sic] *was hung in effigy last night.* [Note: The tradition of hanging an effigy of St. Patrick was tolerated in the nineteenth century to symbolize anti-Catholic, anti-immigrant feelings among the native-born.]

[April 7, 1884]
They bring the male over in a dog sleigh because the ice is not strong enough to hold a horse.

[April 12, 1884]
They had Maj. Sellers funerel [sic] *today. Almost every person on the island went to it.*

Harold's final record as a schoolboy on Mackinac Island was entered on September 30, 1884:

We left Mackinac at seven P.M. on the Ferry Boat Algomah.

MACKINAC ISLAND SUMMER SCHOOL OF ART

In 1940, Mackinac Island Summer School of Art was established in the Indian Dormitory (now the Richard and Jane Manoogian Mackinac Art Museum) under the direction of artists Thomas F. Daly and Stanley Bielecky. Unfortunately, World War II forced the school to close; however, the two artists continued to create for years afterward. Their paintings are on exhibit in museums today and are often sold by auction.

MACKINAC PUBLIC SCHOOL
AT THE INDIAN DORMITORY

From 1867 to 1961, the Mackinac Public School was located in the Indian Dormitory. The front of the Indian Dormitory was enlarged to accommodate the school; however, in 1965, Mackinac Island State Park Commission, the governing body of Mackinac State Historic Parks, purchased the property from the Mackinac Island Board of Education and the Commission, removed an addition and restored the building to its 1838 appearance.

MRA TRAINING CENTER AND COLLEGE

Before she developed the onscreen persona that struck terror in the hearts of potentially philandering husbands as the bunny boiler in *Fatal Attraction* and fear in the hearts of children as the thoroughly evil Cruella de Vil, actress Glenn Close spent summers as a student in the Moral Re-Armament (MRA) complex at Mission Point.

The Moral Re-Armament, an educational and nondenominational spiritual organization (or brainwashing cult to some), was established by Frank Nathan Daniel Buchman, a Pennsylvania native born in 1878. In 1902, he was ordained as a Lutheran minister. Buchman's early attempts to form a church in suburban Philadelphia and to build a home for mentally ill boys failed, leaving him disheartened and exhausted. On the advice of his doctor, Buchman took a long, restful trip to England, where he attended a religious convention that set him on a path traveling and speaking around the globe, preaching that world peace could be accomplished one person at a time. Moral re-armament, not military re-armament.

Glenn Close began her career in show business as a choir member in the old Moral Re-Armament Center on Mackinac Island. *George Frey/EPA-EFE/Shutterstock.*

In India, Buchman began a friendship with Mahatma Gandhi that lasted a lifetime. He spent two years in China, where he met with Sun Yat-sen, "the father of modern China." Buchman returned to England to establish the MRA, whose message that the actions of individuals could achieve world peace and defeat Communism resonated with audiences in prewar Europe. Senator Harry Truman; novelist Daphne du Maurier; and Charles Edison, secretary of the navy and the son of Thomas Edison, praised the MRA's guiding principles, called "the Absolutes": absolute love, absolute purity, absolute honesty and absolute unselfishness. But not everyone was a fan of the MRA. In *Uncommon Friends: Life with Thomas Edison, Henry Ford, Harvey Firestone, Alexis Carrel, and Charles Lindbergh* by James Newton, aviator Charles Lindbergh is quoted as saying, "MRA is made up largely of people who have been unable to solve their own problems, and who, therefore have gone out to solve the problems of mankind."

Upon Frank Buchman's death in 1961, the U.S. Congress celebrated him in the *Congressional Record* and published tributes that arrived from officials

in foreign countries. The prime minister of Thailand noted, "We shall find through Moral Re-Armament the basis for unity in southeast Asia." A Nigerian government official offered, "Moral Re-armament can give to our people and the country the moral revolution which is the only basis of survival in a world of conflict and chaos." Members of the British House of Commons said, "Moral Re-Armament points the road the great movements of the common man everywhere must take if they are to fulfill their role of uniting a disintegrating humanity."

Along with praise, the MRA attracted controversy, beginning with MRA founder Frank Buchman's admiration for Adolf Hitler. His 1936 quote, "I thank God for a man like Hitler," was disavowed, but the words haunted him until his death. By the time the MRA had established itself on Mackinac Island, it had gained a reputation as a cult. A British magazine stated that members "have given every penny they possessed and have surrendered themselves completely to the task of spreading the message." It added, "Aware of the terrible problems of modern society, and lacking the essential knowledge of their origin, such people are comparatively easy meat for such movements as Moral Re-armament....Quite openly they are discouraged from thinking for themselves" It continued, "His followers seem ready to quote his words parrot fashion." It was these cult-like features that actress Glenn Close disclosed years later in interviews about her experience with the MRA.

The MRA chose to establish itself on Mackinac Island at the suggestion of Mrs. Henry Ford. Initially, the MRA held meetings in the Grand Hotel and the Island House Hotel, but the hotels could not accommodate the growing crowds (in some years as many as eighty thousand attendees) who traveled to Mackinac from eighty-six countries around the world. Seeing the need to expand, the MRA purchased buildings (including Cedar Point, which it razed) and acres of land on which to build a permanent conference center at Mission Point. In 1956, a citizens group was formed to stop the MRA from expanding on Mackinac Island. The group voiced concerns that the MRA planned to change the historic nature of the island by turning it into a religious center, but officials dismissed their concerns as "misguided protests of a small though noisy group of disgruntled persons."

Nonetheless, work continued, and the MRA destroyed more of Mackinac's historic buildings. When finished, the MRA complex consisted of nine buildings; with the exception of the Mission Point Resort and a cottage reborn as the Small Point Bed & Breakfast, none remains. With support from Hollywood moguls like Alfred Hitchcock, Cecil B. DeMille

and Louis B. Mayer, who purchased modern equipment that was hauled across the ice on a flat-top barge named *The Beaver*, the group produced Hollywood-style films that spread the word of the MRA to the rest of the world. The largest steel-frame structure on the island was constructed to house a state-of-the-art film studio, recording studio, sound stage and film processing lab. An eight-hundred-seat theater was built for MRA plays and singalongs by the group Up with People, in which Ms. Close performed. Meeting rooms, dining rooms and two dormitories were constructed on the hillside above the theater. MRA also constructed a separate guest house called Straits Lodge.

While work continued on Mackinac Island, the MRA established its European headquarters in Caux, Switzerland, and it was there that Glenn Close was first introduced to the MRA. When Ms. Close was a child, her mother and her father, a Harvard-educated surgeon, left the family's Connecticut home to live in the former Belgian Congo in Africa. As followers of the MRA, Mr. and Mrs. Close deemed that rather than allowing the children to remain with relatives in the familiar surroundings of the family's home in Connecticut, the best place for the children to live would be at the MRA European headquarters in Switzerland, where Ms. Close would live with her siblings until the age of twenty-two. As a teenager, she traveled to Mackinac each summer. The MRA left its mark on the actress, who told the *Hollywood Reporter* on October 15, 2014:

> *I wouldn't trust any of my instincts because* [my beliefs] *had all been dictated to me.…You basically weren't allowed to do anything, or you were made to feel guilty about any unnatural desire. If you talk to anybody who was in a group that basically dictates how you're supposed to live and what you're supposed to say and how you're supposed to feel, from the time you're 7 'til the time you're 22, it has a profound impact on you. It's something you have to* [consciously overcome].

Although she rarely speaks of Up with People in a positive tone, perhaps she might credit the MRA and her experiences performing in Mackinac for preparing her for an acting career in blockbuster movies and her Tony Award–winning performance in the Broadway musical *Sunset Boulevard*.

MACKINAC COLLEGE

In December 1965, the *Detroit Free Press* bemoaned the lack of higher education opportunities up north. "The eastern half of the Upper Peninsula and the top part of the Lower Peninsula are now one vast education wasteland. There are no four-year colleges."

Five months earlier, the *San Francisco Examiner* announced the grand opening of Mackinac College: "Directors of Moral Rearmament announced yesterday they will turn over the organization's conference center to Mackinac College, a proposed four-year liberal arts school to open in September 1966."

Plans to open an MRA college had been in the works since Peter Howard, leader of the Moral Re-Armament movement, hatched a scheme to fill the unused MRA conference center during Mackinac Island's bleak winter months. Perhaps it was the time Mr. Howard spent racing down on the icy hills of St. Moritz as a world champion bobsledder that fueled his enthusiasm for the frigid climate of Mackinac Island in winter. Classrooms, residence halls, apartments to house faculty members and a cafeteria large enough to accommodate one thousand students already existed, but the college would need a library. Raising money to build and fill a library was not a problem for Mr. Howard, who immediately embarked on a fundraising tour of Latin America. Unfortunately, Mr. Howard died of pneumonia while visiting Peru, but his plans for the library came to fruition thanks to the hard work of many volunteers from eight countries who built the Peter Howard Memorial Library.

Not all the "volunteers" were happy with the arrangement promised by the new administration. *The Record* of Hackensack, New Jersey, learned that two Indonesian students who spent the winter months working for the college did not receive the college education they were promised. Mr. L. Parks Shipley of the MRA offered an explanation: "The program may have been badly explained to these particular students. And then, too, we may have invited the wrong young men to participate."

Despite these problems, construction on the campus continued. With a gift of more than $1.5 million from William Clark, heir to the Avon cosmetics fortune, the college erected a two-story building to house science laboratories. The federal government provided $556,691 in funds to build a new physical education building. The State of Michigan donated four acres on Lake Huron for an off-campus marina.

The Mackinac College Board filled the faculty with distinguished scholars from around the world, including physicist Samuel Douglas Cornell,

executive director of the National Academy Sciences who became the school's president; Daniel Yu-tang Lew, the Harvard-educated diplomat who served with the Chinese mission to the United Nations and founded the Lincoln Society in Taiwan and who joined the college as a Senior Fellow in political science; and Franklin Chance, former technical director of Pfizer International, who joined as a professor of mathematics and worked construction with summer students. The newly appointed director of physical education, Matti Harhi, a former Finnish national collegiate ski jump champion, proclaimed, "Mackinac College will emphasize all winter sports while striving to recruit and train Olympic caliber skiers." With support from the dean of students, two-time Olympic gold medalist Richard Wailes, the program showed great promise.

In December 1965, President Cornell explained to the *Idaho Free Press*:

> *Mackinac College aims to be at the forefront of a new and necessary development in higher education. Along with a firm devotion to the highest standards of academic excellence in its curriculum. Mackinac will be explicitly concerned with the building of character and high purpose in young men and women. Education must look to the cultivation of a sense of moral responsibility as well as to the development of intellectual capacity in youth if mankind is to meet the staggering problems and seize the limitless opportunities of the modern world.*

The new minted curriculum offered a wide range of courses: Art, Biology, Drama, Economics, English, History, Mathematics, French, German, Spanish, Music, Philosophy, Physical Education, Physical Sciences, Political Science, Psychology and Sociology—all at the cost of $2,500 per term. Students who could not afford the tuition were given jobs on campus.

In 1966, the college enrolled a smaller than expected initial class of only two hundred students. President Samuel Douglas Cornell enthusiastically declared, "A newly fresh idea in the hands of a few can shift the established momentum of a great mass." On opening day, President Cornell welcomed students:

> *We have before us the greatest adventure of our lives. We are out to build a concept of education to meet the challenge of an age that is characterized by its breathtaking opportunity and its appalling danger. Can we learn together to take the best in the human mind and spirit, to infuse it with the essence of the knowledge and wisdom of the ages, to kindle it with the spark of high*

purpose, and thus to produce men and women with the intellectual grasp, the carelessness of self, the understanding of issues, and the lion hearts to match the time in which we live? For we are out to do nothing less. There will be nothing easy about this road. Real learning is not easy. But it will be an exhilarating road, an unexpected road, a road of beauty and of danger, an infinitely rewarding and satisfying road.

In the years following its opening in 1966, the college failed to attract enough students to meet its financial obligations. Enrollment continued to decline, and in 1970, the college graduated just thirty students, its first and only graduating class. The following year, the MRA ceased operations on Mackinac Island and put the complex up for sale. The *New York Times* reported, "The 32-acre campus overlooking Lake Huron is valued at $13 million but is up for sale for $7.5 million."

Since its inception, the MRA relied on large donations from high-profile supporters and the work of unpaid labor to keep the college afloat. With few tangible results to show for the project on Mackinac, donations dried up.

The MRA has been gone from Mackinac Island for more than fifty years, but the movement continues to operate under the name Initiative of Change International from its headquarters in Caux, Switzerland.

THE REX HUMBARD CENTER FOR CHRISTIAN DEVELOPMENT AND MACKINAC COLLEGE

Mackinac College was part of a dream hatched on a sizzling summer afternoon in Hot Springs, Arkansas, when thirteen-year-old Alpha Rex Emmanuel Humbard stood outside a Ringling Bros. and Barnum & Bailey Circus tent. The boy watched from outside because he didn't have enough money for a ticket, and besides, his family didn't approve of worldly diversions. As he watched the large crowd push and shove until they filled the tent, he saw before him the business model that would set him on a path to worldwide fame and unimaginable riches—a path that led him to Mackinac Island before retiring in Florida at the age of eighty-eight.

That business model was a tent bursting with people, but in his dream, the crowd wasn't there to laugh at clowns, hold their collective breath as aerial acts performed high above or scream when a lion tamer suddenly stuck his head between the jaws of a wild beast. No. In his dream, the crowd was there

to listen to him preach. Humbard, who preferred Rex Humbard to his given name, traveled for ten years setting up his tent in small towns throughout the United States, attracting crowds wherever he went. But after a decade on the road, Rex wanted more than just a tent. When it came time for him settle down with his family (which eventually would include his charismatic wife, Maude Aimee; daughter, Elizabeth; and sons, Rex Jr., Charles and Don, all of whom worked in his church) the Arkansas native chose to live in Ohio, where he found an old movie theater in which he could preach to former Bible Belt folks who migrated north to work in factories. He called his church the Cathedral of Tomorrow. And it was no ordinary church—it grew and grew. The Cathedral of Tomorrow eventually held 5,400 people and even featured a revolving restaurant and television studio, where he broadcast to an audience of 20 million followers in far-flung countries around the world, including the former Soviet Union. Elvis Presley was a loyal viewer, and Humbard spoke at the singer's funeral in 1977. Raising $4 million to cover the cost of the church didn't faze Humbard, as he continued to spend money and acquire wealth. He spent money with abandon (e.g., a private jet big enough to carry his forty-member choir plus a dozen friends). Although the Cathedral alone operated at an annual loss of $500,000, he told the *South Bend Tribune*:

> *I don't read in the bible where it says to pay off the mortgage and rejoice. The Lord said go into the world.*

The *New York Times* reported:

> *As Mr. Humbard often told it, he found his electronic calling in 1952 while watching a Cleveland Indians-New York Yankees baseball game on a TV set through a window in O'Neil's department store in downtown Akron, Ohio.*
>
> *"I viewed one of the first television programs broadcast live to northeastern Ohio," he wrote. "I was impressed with the power and magnitude of this new invention, television, as it reached those of us gathered in front of that window."*

During his career as a preacher, Humbard purchased more than three hundred televisions, an advertising agency, Unity Electronics, Unity Plastics & Wire, Adcraft Typographers, a twenty-four-story office building, a Holiday Inn, air rights above his real estate holdings and a girdle factory, which he eventually sold. In an interview with the *Tucson Daily Citizen*,

Humbard told a reporter that he sold the Real Form Girdle Company (which advertised advanced features such as a removable crotch) because "the thing quit making money because you women quit wearing girdles and started wearing pantyhose."

Undeterred by business failures, when Humbard learned that a college was for sale, he hopped into his private jet and headed north to Mackinac Island to tour the Mackinac College campus. He liked what he saw: a ready-made college in a remote setting—perfect for molding young minds while they lived away from their families. The on-campus television studio where Humbard could continue broadcasting his message sealed the deal. In April 1971, he told the *Akron Beacon Journal*, "I've wanted to start a college and seminary for 10 years, but I never had the facilities to do so. I thought about building facilities near the Cathedral [in Cuyahoga, Ohio], but Mackinac College will work out much better."

Before the former trustees of Mackinac College cashed Humbard's check, they hired a detective to check his credit rating. After all, Humbard had been nearly bankrupt at one point until Jimmy Hoffa's Teamsters Union Pension Fund bailed him out of crushing debt. When Dunn & Bradstreet confirmed that Humbard's creditworthiness was good, Humbard forgave the trustees for doubting him. He told a newspaper, "We all make mistakes. But they decided I never purposely did anything wrong. So they decided to do business with me."

Before the college opened, Humbard commissioned a feasibility study from the Academy for Educational Development, which determined that "an academically sound institution could be operated on the island if the Cathedral of Tomorrow was willing to make the necessary financial commitment to the enterprise, over and above the income expected from a total of 1,000 students."

Humbard anticipated additional revenue coming from Christian family retreats on the island planned for the summer months each summer when classes were not in session. Visitors to Mount Humbard, an on-campus ski lodge, would provide money during the winter break.

According to the *Arizona Republic*:

> *For $100 or less per head, vacationers get scenic beauty, 20 bountiful meals, a modern dormitory room on this island on Lake Huron and daily "soul winning" seminars….Before the season ends on Labor Day weekend, said Humbard, the center will be operating at capacity of 600….The evangelist would continue to use the campus for "vacations with inspiration" summers.*

Lansing Journal reported on the college's purposed fields of education:

> *The* [Academy for Educational Development] *report calls for college divisions of humanities, physical sciences, and social sciences, embracing the following 18 departments in which students can take courses: Humanities: English, art, foreign languages, history, music, philosophy, religious studies, speech, drama and theater arts. Physical Science: Biology, chemistry, mathematics, and physics. Social Science: Business administration, economics, education* [teacher training], *political science, psychology and sociology.*

The report also proposed a work-study plan for students who could not afford $2,000 for classes plus $1,200 for room and board. These students were promised paid internships in related fields at Humbard's other enterprises. However, harsh winter weather made travel off the island difficult, and students were forced into manual labor on the island.

In 1972, Mackinac College at the Rex Humbard Center for Christian Development finally opened and welcomed 155 eager students, far below the 1,000 students needed to operate the college. Mackinac College president Roger Kvam was not dissuaded by the low enrollment: "This level is just perfect for us, for everyone to get used to a new school." And Director of Admissions David McBride told the *Miami Herald* that he expected enrollment to reach 1,000 in a few years.

The arrival of the students to this unusual college on a remote island in the middle of the country was heralded by newspapers around the country. Holly Kavlie of North Dakota reported that she received her invitation to join the campus directly from God. She told the *Akron Beacon Journal*, "He gave me a grant to come."

The *Daily Oklahoman* reported that a student from Florida, surprised that taxis operated with real horsepower, said, "I heard there were no cars, just horses. But I thought it was a joke." Another student told a reporter, "There's no way to describe it. You have to believe it to see it."

Mackinac College was a Christian college of no particular religion, and as such, students were not compelled to attend religion classes. But all students were bound by a set of strict rules. Dee Senkbile of Nebraska told a reporter, "I love the rules," which the *Red Deer Advocate* of Alberta, Canada, described in part as prohibiting excessive public displays of affection or couples loitering in little-used or darkened areas of the campus. Also prohibited were profanity, smoking, gambling, cheating, drinking and the use of unprescribed narcotics and any other mind-altering drugs.

There was a time when cars were permitted on Mackinac Island. The City of Mackinac banned cars in 1898; however, the state park allowed cars until 1901. The most famous car on the island, a "locomobile," driven by Earl Anthony, forced the island-wide ban. *National Archives, no. 169153938.*

The Canadian newspaper also described the college's unfashionable dress code: "The college dress and grooming code stipulates that men cannot wear hair below their collars. They must wear shirts and ties to classes, while females must wear skirts or dresses."

But before the end of the second term, the college was in financial difficulty, and rumors spread that it would close. Faculty salaries were cut by 40 percent, and the entire maintenance staff was laid off. With no workers to maintain the campus, students were pressed into service. Each spent three hours per week sweeping 500,000 square feet of floor space, washing hundreds of windows, maintaining the grounds and otherwise keeping the place in order. But apparently, they didn't complain, at least not to newspapers. The *Evening News* of Sault Ste. Marie reported:

> *There has been an unusual devotion to the place since the beginning. The entire college family feels a strong attachment to the school. Most will tell visitors and frequently share with each other the special attraction Mackinac holds for them. The lack of finances hasn't dimmed the enthusiasm…. Everyone terms the three hours he is giving "good citizenship."*

But as financial difficulties plagued Mackinac College, Humbard appealed to devoted members of his worldwide television audience to each contribute $10 to buy a textbook or more if they could afford it. Humbard sold "Cathedral notes" worth $12 million to thousands of investors. The SEC deemed the practice of selling "Cathedral notes" as the illegal sale of unregistered securities. Humbard was ordered by a federal court to repay his investors, and a state court took over church finances. Humbard protested, "It's a religious right of the members of our church to let us have money to propagate the gospel." Many purchasers of "Cathedral notes" considered the courts' involvement as harassment and did not accept money the courts deemed they were owed.

In 1973, the Cathedral of Canada, the Canadian subsidiary of the Cathedral of Tomorrow, sent $138,000 to rescue the college after lack of operating funds forced a three-week delay in reopening after the spring break, but it was not enough to keep the college afloat. Throughout the ordeal, Humbard continued to operate as though the college had no financial difficulties. Humbard billed the college $200,000 for promoting it on his Cathedral of Tomorrow holiday TV show. He petitioned Governor Milliken to extend the airport runway and build a taxiway near his Mackinac mansion, which Rex Humbard Jr. proclaimed to the *Akron Beacon Journal* would not benefit the Humbard family, who lived next to the airport: "We wanted to lengthen the runway so the Winter vacationers wouldn't have to be brought in by small plane, that's all."

In June 1973, Humbard abruptly closed the college. When asked for a comment, Charles Schoenherr, who was at the time both dean and vice-president of Mackinac College, simply told the *Battle Creek Enquirer* that "the well ran dry."

LOST ENTERTAINMENT

Christiaan Huygens's parents provided exceptional homeschooling in foreign languages, mathematics, history, geography, dance lessons and horseback riding for their son until the age of fifteen, when he enrolled in the University of Leiden, where he studied mathematics and law. Poor health prevented him from seeking regular employment, but his family's wealth allowed him to tinker, explore and invent with abandon. Piggybacking onto Galileo Galilei's research on the properties of pendulums, Huygens built and patented the pendulum clock, which increased the accuracy of time measurement to within fifteen seconds per day. Christian and his brother Constantin spent hours grinding and polishing telescope lenses until they were able to clearly see the rings of Saturn and its largest moon, Titan, which Galileo had failed to see with his telescope. Huygens proudly showed off his telescope to mathematician Blaise Pascal and debated the laws of gravity with Sir Isaac Newton. His devotion to the study of optics resulted in the invention of an apparatus that focuses light on a concave mirror and a series of lenses to project images on glass plates across a darkened room, and it is the invention of this learned man that provided entertainment to snowbound children on Mackinac Island.

Huygens later regretted inventing the "laterna magica" and featuring an image of self-decapitating skeleton in his initial "laterna magica" show because he felt that the silly invention would harm his reputation as a scientist; however, Huygens's magic lantern endured through the early twentieth

century, when it was replaced by the invention of the movie projector. According to the Magic Lantern Society of the United States and Canada, the magic lantern was introduced to America in Salem, Massachusetts, on December 3, 1743, and somehow, a little more than a century later, the magic lantern made its way to Mackinac Island. In *A Boy at Fort Mackinac: The Diary of Harold Dunbar Corbusier 1883–1884, 1892*, Phil Porter noted, "The faithful Reverend Stanley [Reverend Moses, the first pastor of Trinity Episcopal Church] never seemed to fail, if necessary walking across the ice from St. Ignace to give his lantern show." On February 1, 1883, master Corbusier recorded in his diary:

> *I weigh 59¼ lbs. and am 50 5/8 inches tall. The ice on the other side of the straits has nearly all been blawn* [sic] *away. We boys went down to Truscotts hall to Mr. Stanley show pictures* [sic] *with his magiclantern* [sic].

Harold's mother, Fanny, recalled that Reverend Stanley "gave magic lantern exhibitions in Truscott's Hall, much to the delight of the children.… He also served the church at St. Ignace, where he remained much of the time in winter but frequently crossing the ice, sometimes walking eight miles." Whether Reverend Stanley's magic lantern shows featured religious images designed to teach children the Christian way or expand the children's world with images of other countries, we'll assume that the images were less disturbing than Huygens's slides of self-decapitation.

Truscott's Hall (aka Truscott's Opera House) was rented for twelve dollars per performance, but perhaps owner George Truscott, an original member of the Episcopal church, gave Reverend Moses Stanley a discounted rate to stage his magic lantern shows.

The Fenton Opera House, of similar size, also rented for twelve dollars per performance, boasted a larger stage and the services of a theatrical team master by the name of Frank Chambers. In the nineteenth century, opera houses brought art and culture to small towns and cities such as Detroit. These palatial theaters did not necessarily ring out with the sound of tenors, sopranos and baritones singing the works of Mozart and Wagner, as evidenced by the fare at the Fenton Opera House, where on July 12, 1890, a show was performed by Mrs. Tom Thumb and her second husband, Count Primo Magri, vaudeville performers affected by dwarfism.

The Corbusier family, who lived on Mackinac Island for a brief time in the late nineteenth century while William Corbusier served as the post surgeon at Fort Mackinac, tended to enjoy entertainment of a serious nature. While

General Tom Thumb and his wife, Mrs. Tom Thumb, earned millions of dollars as circus performers. Following the sudden death of her husband, she and her second husband thrilled audiences at Fenton's Opera House. *Library of Congress, cph3a48490//hdl.loc.gov/loc. pnp/cph.3a48490.*

Dr. Corbusier saw to the island's medical needs, his wife, Fanny, devoted herself to their five young sons, allowing them freedom to pursue their interests, provided they did well at school and attended church regularly. Fanny recalled the family participated in activities at the church:

Every summer we had a fair for the benefit of the church. There was much musical talent among the visitors, and we gave fine vocal and instrumental concerts. At one in August 1883, Mrs. Louis Brechemin from Fort Brady and Mr. David Carter of Detroit were among the singers. Fancy articles were sold and refreshments served.

[Dr. Corbusier] assumed charge of the Sunday school and organized a class of adults for the study of the Bible. In summer he drew a large class, as his many years among the Indians and his study of ethnology gave him an insight into the teachings of the Old Testament that few men have. He selected many books for the Sunday school library which contained stories of the mountains and woods, trapping and canoeing, habits of wild animals, and histories, such books as the children of the village had never seen before and which interested them more than the stories of good and bad little boys, which it had formerly contained.

The Corbusier family spent time enjoying nature, especially Mackinac Island's thick woods, which Fanny treasured after spending years in Nevada, New Mexico and the Arizona territories:

We had been so much at stations where there were only a few trees that the woods here were a great delight to us. When we arrived, the greens of the maple, beech, poplar, oak, etc., were beginning to brighten the darker shades of the hemlock, cedar, spruce, pine and juniper among which they were interspersed. Wild flowers were beginning to bloom, and soon we found them wherever we strolled—trailing arbutus, moccasin flower, Indian pipe, blue gentian, and anemone or wind flower. At the base of Fort Holmes, hill ferns and brakes [various types of ferns] luxuriated and the maidenhair was the daintiest of them all.

Fanny's mother "loved to go after berries and one day came back from Bois Blanc Island so badly bitten by mosquitoes that she was sick the rest of the day."

Fanny allowed her son Phil, who was often sick, to keep a calf and a rabbit as pets. She said that "with ears thrown back [the rabbit] would jump upon

and look at the calf as it lay on the grass. The calf leaped to its feet to throw up its tail and cavort about the rabbit." Her son Harold preferred hunting rabbits rather than cavorting with them, as he wrote in his diary that he rose from bed early to check his rabbit traps.

Not a fan of Mackinac Island's long winters, Fanny would consent to braving the snow and ice only if she would "be pushed about on a sled." But Harold, his father and his brothers relished in winter activities unique on the Island. From Harold's diary:

[February 2, 1883]
We went down to the government dock to see the men cut ice, the ice is 17 inches thick.

[March 17, 1883]
All of us boys went to Devils Kitchen twise, we made an fire.

[April 28, 1883]
We went into the woods at the foot of the hill on the west side of Fort Holmes to gather maple sap. We taped eleven trees and brought home four galons [sic] of sap and would have had more but we wasted a great deal.

On January 4, 1884, Harold enjoyed skating across the ice propelled by a sail, as he described in his diary: "Papa made a sale so we could sale with it when we were skating." In her book, Fanny wrote, "Father made sails to carry. One kind was on a bamboo pole bent as a bow and carried on one shoulder, and another was a square sail to carry on the back, often with a topsail to raise above the head."

Like other families on the island, the Corbusiers celebrated holidays according to the local tradition. Instead of consuming green beer and corned beef, as is the tradition today, Harold noted that on March 17, 1884, "St Patric was hung in effigy," an anti-Catholic practice outlawed in New York State in 1816 but legal in Michigan. On Independence Day, the fort fired a thirty-eight-gun salute at noon to announce the beginning of old-fashioned games: rowboat races, greased pole climbs and jumping matches. Of course, there were fireworks. Harold noted on July 5, 1883, "Last night we set off a great many fire works. Claude hurt his hand very badly last night." When Harold returned to Mackinac Island years later as a young man, he celebrated Independence Day at the Grand Hotel: "I danced twelve dances. I am beginning to waltz a little."

On Halloween, children on the island played "bobbing for apples," which required a child to stick his head in a bucket of water and attempt to retrieve an apple in his teeth. However, in 1883, no apples could be found on Mackinac Island, and the children had to make do with potatoes. On Christmas, most Mackinac Island families attended church and ate a rich meal followed by exchanging small gifts. The Corbusier family's Christmas dinner meal included chickens, ducks and turkeys brought over on the ice bridge. After dinner, Harold received gifts of a knife and a calendar of American history.

Soldiers posted to Fort Mackinac enjoyed simple forms of entertainment such as playing cards and billiards in the barracks or drinking ice-cold beer in the canteen, careful not to drink too much or fall into debt, crimes punishable by a reprimand or court-martial. One commissioned officer, Captain Leslie Smith, went so far as to rescue soldiers from the depravities of excess alcohol consumption and unpaid bar tabs when he prohibited village tavern owners from serving soldiers under threat of prosecution if they ignored his directive. Soldiers organized shooting contests with the Cheboygan Gun Club and played baseball with the Diamond Baseball Club of Cheboygan Baseball Club, often resulting in minor injuries treated by the post surgeon. On holidays, suspension of routine duties allowed the soldiers to join villagers in the park or on the beautiful shoreline.

In 1887, soldiers issued evening or overnight passes enjoyed entertainment on and off the island. As Phil Porter reported in his book *A Desirable Station: Soldier Life at Fort Mackinac, 1867–1895*:

> *Passes were always in demand but especially so during the summer when the weather was pleasant.…Most often soldiers on pass simply went to town for an evening in the saloon, a meal at one of the hotels or a party at the roller-skating rink. Some traveled to St. Ignace, Cheboygan or Mackinaw City while others went fishing, hunting, [or] sailing.…Eight enlisted men from the Tenth Infantry went to see a show in the village on August 6, 1881 and two weeks later a dozen men took an excursion to the Les Cheneaux Islands on board the Messenger.*

Today, Mackinac Islanders can be seen cross-country skiing, but they may not be aware that downhill skiing was once possible, although few, if any, traces of an alpine ski village remain on the island. In the winters of 1971 and 1972, visitors schussed down the meticulously groomed trails of Mount Humbard and enjoyed apres ski refreshments at the Bavarian-

themed Paradise Lodge. Hoping to establish a collegiate ski team at Mackinac College, Rex Humbard hired two instructors—his brother, a former Olympic skier, and a Las Vegas gospel singer/ski champion—to lead a team to victory. In less than four months, 165 acres were transformed into ski village, complete with a 150-foot run, a 650-foot run, a twenty-eight-chair lift, cross-country trails, a toboggan slide and an ice skating rink. Lack of snow and numerous complaints from residents about soil erosion, a result of clearing of trees on the site, doomed Mount Humbard and Humbard's proposed collegiate ski team.

LOST INDUSTRY AND COMMERCE

Blame it on a worm. A tiny worm less than two inches in length. A hairy worm with a horned tail. A worm rejected by Mahatma Gandhi in favor of cotton. A picky eater that prefers mulberry leaves, specifically white mulberry leaves. And blame it on the French for breeding the worm that killed a thriving economy on Mackinac Island.

As early as 1670, French fur traders arrived on Mackinac Island with the intention of making a quick and healthy profit by cheating the Anishinaabeks. According to an account by former congressman Bart Stupak, published in the *U.S. Congressional Record* (volume 142, no. 110):

> *In 1670 Jesuits landed on Mackinac Island, situated between the Michigan's Upper and Lower Peninsulas in the Straits of Mackinac. The missionaries, along with members of the Huron tribe, intended to teach the Chippewa and Ottawa Indians the way of the Lord. However, within a year the Jesuits left Mackinac Island and relocated at St. Ignace, named for St. Ignatius Loyola. The island had proved to be agriculturally weak and the land to the north in the Upper Peninsula was perfect for growing corn. From St. Ignace the missionaries traveled to surrounding areas in attempt to spread the Catholic faith.*
>
> *The Jesuits became the peacekeepers of the region. In the late 1670s French fur traders entered the straits to buy furs from the American Indians. Unfortunately, the French used less than honorable tactics. It came to the*

attention of the church that the fur traders were selling brandy to the Indians with the intention of taking the furs, without paying, once the Indians got too drunk to understand what was happening.

Despite these and other deceptive practices, the relationship between the Anishinaabeks and French fur traders lasted for generations. The Anishinaabeks benefited from trade goods—such as blankets, metal tools and cloth—yet were not dependent on French for survival. For centuries, the Anishinaabeks provided for themselves, taking only what they needed, wasting nothing. Animals provided not only meat rich in the form of much-needed protein but also skins for clothing and shelter, bones for tools and sinew for sewing. European goods just made life a little easier. Brass kettles replaced ceramic pots, labor intensive to make and easy to break; heavy-duty iron needles replaced bones for sewing clothing; and ready-made woven blankets were easy to transport. The French traders, however, depended on fur from the Anishinaabeks to earn a living and meet the demands of European and American men who hungered for the latest fashion: the beaver hat.

When French fur traders and Anishinaabeks established families, they combined the skills and intelligence of both cultures to form a new culture: the Métis. Author Grace Lee Nute described French fur traders who dressed in a mix of French and Anishinaabek clothing:

A short shirt, a red woolen cap, a pair of deer skin leggins which reach from the ankles a little above the knees, held up by a string secured to a belt above the waist the "breech cloth of the Indians," and a pair of deer skin moccasins without stockings on the feet. The thighs are left bare.

Author Nikki Rajala, a descendant of French Canadian voyageurs, explained the significance of the red sash, as appeared on her website:

French-Canadian voyageurs exuded joy and verve. But, working on the lowest rung of workers in the fur trade hierarchy, they had few resources to express that lively style. Their clothes—made of plain homespun linen or wool—were worn hard. When the fabric wore out, canoemen switched into buckskins, trading for them with the Ojibwe. So adding a red sash, functional as well as striking, was an easy way to spice up a tatty wardrobe….

To freshen up after 6 weeks of wearing the same things, it was traditional to stop to clean up a few miles out from the rendezvous (at Hat Point near

Demand for beaver hats fueled the fur trade at Mackinac Island. *Library of Congress, ds00663//hdl.loc.gov/loc.pnp/ds.00663.*

Grand Portage). The paddlers wanted to look their best, even if their clothes were ragged, stained and patched. Their sashes added sparkle, whether or not the voyageurs could untangle the knots in the long fringes….

It could be a place to tuck a knife, fire steel, or personal items (nobody had pockets), a tumpline to carry heavy items, a tourniquet, sling or splint for an injured limb, a rope. Individual strands could be pulled out if a single thread was needed.

No outfit was complete without a DIY mosquito repellent: a mixture of bear grease and skunk urine.

The Anishinaabek women worked alongside their European husbands, skinning and preserving fur from beavers trapped by their husbands, paddling the family canoes laden with beaver pelts across the treacherous straits to Mackinac Island and setting up temporary homes on the island. Hundreds of families arrived on Mackinac each summer to socialize and make deals. While one parent might speak only French and the other parent, usually the mother, spoke the language of the Anishinaabek people, their multilingual children could easily switch between languages to ensure their parents got a fair price.

The French trade continued until the 1760s, when the British captured French Canada. Unlike the French, British fur traders did not form families with the Anishinaabeks and did not offer gifts, as was the custom.

Mackinac Island would not have become the leading fur trade industry in America without preferential treatment from the U.S. Congress, a shady real estate deal with former vice president Aaron Burr, an opium smuggler and seven German flutes. Yet John Jacob Astor, the German immigrant who made a fortune in the fur trade and created jobs for hundreds of Mackinac Islanders, never set foot on Mackinac Island. When Astor set sail for America at the end of the American Revolution, he carried with him twenty-five dollars in cash and seven flutes that he hoped to sell in New York. On board, he met a fellow passenger, who gave the twenty-one-year-old a crash course in the fur trade business as the ship crossed the Atlantic. According to *The Life and Ventures of the Original John Jacob Astor*:

He told him of the respective prices of skins in America and London; instructed him where to buy, how to preserve, pack, and transport the peltries. He gave him the names of special dealers in New York, Montreal and London, and told him the season of the year when furs were most abundant.

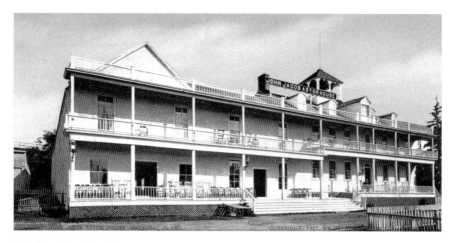

The American Fur Company warehouse as it appeared in the early 1900s. *Library of Congress, det4a31694//hdl.loc.gov/loc.pnp/ det4a31694.*

Robert Bowne, an aged and benevolent Quaker, long established in the business of buying, curing and selling peltries, needed a clerk, and considered John Jacob Astor's application favorably.

John Jacob Astor set himself with all his heart to learning the business, on the principles that knowledge is power.

Astor struggled in New York City to support his growing family by selling the musical instruments and fur, and by the age of thirty-seven, Astor's wealth totaled $250,000.

To gain a foothold in the Great Lakes, John Jacob Astor purchased an interest in the Mackinaw Company, a well-established British fur trader that later merged into Astor's American Fur Company. The deal included its factory on Mackinac Island and exclusive trading routes. The War of 1812 interrupted fur trading, but when peace was declared, Astor's fortune rebounded because he persuaded Congress to prohibit fur trade by foreigners, thereby eliminating any independent French and British traders from entering the market. Revenue from the American Fur Company allowed Astor to enter the drug smuggling business; with the purchase ten tons of Turkish opium smuggled into China, he expanded the fur trading business and brought wealth to Mackinac Island.

When the war ended, Astor recruited Ramsay Crooks to reboot trade at the American Fur Company. Crooks sailed from Buffalo aboard what a fellow passenger who boarded in Detroit described as a "crazy old vessel without any convenience of table, furniture or provisions" or a reliable

Left: A wooden desk belonging to the American Fur Company. *From* Early Mackinac *by Meade C. Williams.*

Right: Scale for weighing pelts purchased at the American Fur Company. *From* Early Mackinac *by Meade C. Williams.*

captain. Undeterred by the lack of amenities, Crooks commandeered the schooner's skiff and went ashore to purchase food, cutlery and dishes before he allowed the captain to resume the voyage to Drummond Island, where Ramsey hoped to find someone to take him to Mackinac Island. The ship became becalmed on the St. Clair River for ten days, during which time Crooks purchased a sheep from a nearby island to supplement a menu of pork and bread. The schooner finally reached Drummond Island after a month of travel. A fur trader bound for Mackinac Island offered Crooks passage and cups of corn soup for nourishment during the two-day journey.

Although grateful to this man, LaCroix, for transporting him to Mackinac, Crooks, a Scotsman who reluctantly pledged his allegiance to the United States in order to continue to trade, resented the Frenchman's presence and the presence of other foreigners who operated on the island despite a federal law prohibiting foreign fur traders.

Yet when Astor realized that without the experienced French traders and their Anishinaabek contacts, the American Fur Company would not prosper, he made use of a loophole that allowed the government's Indian agent to vouch for foreigners. According to a report in the *Iowa Journal of History and Politics* (volume 12):

The Secretary of War gave orders that every facility consistent with the laws be afforded to Astor and his agents. Governor Cass instructed the Indian Agent at Mackinac to license all persons designated by the Scotchman, Ramsay Crooks, Superintendent of the American Fur Company.

In his book *A Desirable Station: Soldier Life at For Mackinac, 1867–1895*, Phil Porter wrote about John Jacob Astor's considerable clout with federal officials:

In 1816 Deputy Secretary of War George Graham expressed the government's desire to support the company's work at Mackinac when he ordered post commander Lieutenant Colon John McNeil to "give to these gentlemen every possible facility and aid in the prosecution of their business that may be compatible with your public duties."

When his interest in the affairs of the American Fur Company declined, Astor purchased real estate, including property owned by his friend Vice President Aaron Burr, whose reputation suffered after he killed Alexander Hamilton in a duel. With the depletion of the beaver population, once estimated at 40 to 60 million, and the introduction of the silkworm, Mackinac Island's fur trade industry ceased to exist.

About 180 years before Silicon Valley made *pivot* trendy, Mackinac Island pivoted—nearly everyone on the island pivoted—from the fur trade to commercial fishing. When the bottom dropped out of the fur trade in the 1830s due to Europe's sudden fascination with silk, islanders rediscovered an abundance of fish in the surrounding waters. As commercial fishing emerged, factories were retrofitted to pack and preserve fish, Mackinaw boats replaced bark canoes and long docks were built to accommodate this new industry. Well, it was not exactly a new industry, but new to Europeans. As evidenced by the excavation of Anishinaabe summer fishing camps, Anishinaabeks fished in these waters for seven hundred years before the arrival of Europeans, though not on a large scale.

No single entity held a monopoly on commercial fishing, and the government did not enact legislation to crush the competition as it had during the heyday of the American Fur Company. Mackinac's commercial fishing flourished without much government intervention. In fact, according to the cooperate program Michigan Sea Grant at the University of Michigan, the state did not begin licensing commercial fisheries until 1865.

Anyone with or without a boat could profit from Mackinac Island's commercial fishing business. Ice for the preservation of fish was harvested during winter months. Mackinac's blacksmiths shod horses with spiked shoes, local cobblers provided men with corked soles to prevent them from slipping on the ice and cutlers made a variety of ice tools specially designed for cutting through thick ice. Sleds were loaded with ice blocks and brought to icehouses for storage in the warmer months. Skilled immigrants who escaped poverty and starvation during Ireland's Great Hunger built the barrels that held the fish transported from Mackinac Island to Detroit, Chicago, Buffalo and beyond, using techniques they had perfected in Ireland's distilleries and breweries. According to Phil Porter, as many as thirty coopers using hand tools (side axes, draw knives and long jointers) worked on Mackinac Island in 1850. In his book *A Picturesque Situation: Mackinac Before Photography, 1615–1860*, Brian Leigh Dunnigan Coopers noted, "The construction of barrels reportedly employed as many as four hundred workers in 1847." Coopers disappeared from Michigan nearly a century ago, but recently there has been a resurgence, as coopers are now in demand fashioning barrels for local wineries and breweries. Modern-day cooper Mark Knisley, who makes barrels in Traverse City, said that barrel making is challenging, but it's "quite gratifying, to take a bunch of pieces of oak and have a war with them to get it round."

Former fur traders turned fishermen discovered a large domestic market for one fish in particular. The humble whitefish, a local staple, eventually found its way onto East Coast menus and into prominent cookbooks. The *Boston Cooking-School of Culinary Science Magazine* recommended a "Special Menu for Midsummer" that included broiled whitefish followed by toasted crackers and Bar-le-duct jelly, a currant jelly invented in the French town of the same name; the "Menu for Music Club" consisted of a simple meal of shredded whitefish, ginger ice cream and Othellos (a kind of early version of Oreos).

Merchants around the country proudly advertised their stock of "Mackinac Whitefish" available by the barrel. In 1848, Edward Root used all caps in a half-page ad in the annual *Buffalo Business Directory* to announce "MACKINAC WHITEFISH." An 1858 travel guide for new immigrants unfamiliar with the ways of Americans promoted Mackinac Island, its pure air and clean water and especially Mackinaw whitefish, "an important article in Western commerce."

Mackinac whitefish overwhelmingly dominated the market; however, other fish—including trout, pickerel and herring—found their way into

barrels aboard schooners and steamships, and fish oil squeezed from the bodies of Mackinac's fatty fishes arrived at tanneries to soften leather, in particular chamois leather, used in glove making.

In the mid-1850s Mackinac Island's commercial fishing industry faced competition from an unlikely rival: a religious community on Beaver Island headed by a man who proclaimed himself "King of Beaver Island." Born in New York State on March 21, 1813, James Jesse Strang—the former lawyer, newspaper publisher and member of the Michigan House of Representative—believed himself to be the rightful leader of the Mormon Church upon the death of its founder, Joseph Smith. Strang presented the church leaders with a letter postmarked days before the murder of Joseph Smith in Nauvoo, Illinois, in which Smith supposedly predicted his own murder and declared Strang, a recent convert who was not well known in the community, his rightful heir:

> *The wolves are upon the scent, and I am waiting to be offered up, if such be the will of God....In the midst of darkness and boding danger, the spirit of Elijah came upon me, and I went away to inquire of God how the Church should be saved. I bowed my head to the earth and asked only wisdom and strength for the Church. The voice of God answered....James J. Strang hath come to thee...he shall plant a stake of Zion in Wisconsin, and I will establish it; and there shall my people have peace and rest and shall not be moved.*

Strang established a small Mormon community in southeastern Wisconsin, while the majority of Mormons followed Brigham Young to Utah. Internal fighting within the community forced Strang out of Wisconsin. Strang and a few followers relocated to Beaver Island. Initially opposed to polygamy, Strang settled on Beaver Island with five wives, and he encouraged islanders to practice polygamy. Polygamy and Strang's prohibition against the consumption of alcohol didn't fare well with the Irish Catholic immigrants living on Beaver Island. The Mormons and the Catholics openly opposed each other, to the point of armed conflict. But as publisher of the island's newspaper, the *Northern Islander* and as a member of the Michigan state legislature, Strang wielded great power over Mackinac Island, as when he stacked the election of officials of Mackinac County with sympathetic candidates. He doled out physical punishments and seized property of those who did not comply with his order to tax non-Mormon landowners. Tired of King Strang's rules, Irish Catholics fled.

For a few years, Strang's community on Beaver Island grew, reaching 2,600 followers. At Strang's order, his industrious followers cleared land for farming, cut timber and harvested fish. Steamers could easily bypass Mackinac Island in favor of Beaver Island, where they picked up supplies that Mackinac Island could not provide in abundance, such as timber.

But the Mormon community and growing economy of Beaver Island did not last for long after the leader's murder. The shooting of James Strang on June 16, 1856, was reported in full detail by newspapers across the United States. This from the *Buffalo Courier*:

> *One of the men fired a revolver, the ball striking Strang in the back of the head, passed around under the skin, coming out near the temporal bones. He then fired a second barrel, the ball of which struck Strang…about level with the nose and passed into his head; the other man then fired a single pistol, the ball from which struck Strang near the vertebral column, at the small of the back, and passed into his body.*

Despite a number of witnesses to the shooting, the two shooters who were brought to Mackinac Island authorities were not charged with the murder and were set free. Strang died a few days after the shooting. Newspapers including the *Buffalo Courier* hoped that Beaver Island Mormon community would dissolve: "[I]t is hoped that his death will break them up, and scatter them abroad."

LOST LAWS

INDIAN AGENCY

In 1793, George Washington had a lot on his mind. Forced to abandon his office while yellow fever ravaged the nation's capital (Philadelphia), he and his cabinet set up temporary headquarters in Germantown, Pennsylvania, where they conducted the affairs of the federal government until the epidemic ended; he mourned the death of his beloved nephew; he laid the cornerstone of the new capitol building in Virginia; he introduced the Proclamation of Neutrality, which declared the nation neutral in the conflict between France and Great Britain; and he threatened legal proceedings against any American providing assistance to any country at war and appointed Indian agents to facilitate trade and "civilize" Native Americans.

But Mackinac must have slipped Washington's mind, as it was not until 1815 that its first Indian agent arrived: William Puthuff, a hard-nosed military man who once evicted a woman and her children from the family's Detroit home because her absent husband supplied whiskey to soldiers. The family successfully sued Puthuff on the grounds that he had no authority to evict the family, and Puthuff was forced to pay $570 in restitution. Soon after he arrived, Puthuff grew suspicious of Elizabeth Mitchell, an Odawa Indian woman who married British surgeon David Mitchell. Determined to believe that Mrs. Mitchell spied for the British, he posted a placard on island church that read (emphasis added):

Whereas a certain Eliz'th Mitchell under a pretense of trading with the savages is and for many years has been, as it has been represented to me, in the habit of holding her private councils with those unfortunate deluded People and of advising with and persuading them to the adoption of measures injurious to their real interests and that of the American government.

I therefore feel it to be my Duty hereby to forbid the said Elizabeth Mitchell to hold any further intercourse with the Indians that may visit this Island either directly or indirectly until further orders from the American Government.

With the blessing of Fort Commander Talbott Chambers, Puthuff denied Mrs. Mitchell the right to fish (the mainstay of her family's diet) and prohibited her from speaking to native peoples. Elizabeth Mitchell left Mackinac Island and returned after Territorial Governor Lewis Cass dismissed Mr. Puthuff as Indian agent for confiscating John Jacob Astor's boats and furs, charging traders a fee of fifty dollars for a license and other derelictions of duty.

Puthuff's replacement arrived in 1819. In his doctoral dissertation, John H. Humins described George Boyd Jr.: "[A]n Easterner he was ignorant about the Indians and inexperienced with frontier life." Though well connected in the Washington political arena, he had worked as a merchant in Georgetown selling "a general line of merchandise, including such items as coffee, tea, gunpowder, sugar, soap, French wine, lumber, glass products and slaves."

George Boyd arrived in June 1819 and quickly got busy taking over for Puthuff. The government allocated $350 for Boyd to rent a house and office, but the Easterner found conditions "hardly habitable" and insisted on having a new house built to his specifications. By the autumn of 1823, a new house plus a blacksmith shop (to fabricate tools and household utensils), a stable and a storehouse had been built for Boyd at great expense to the federal government. In his dissertation, Humins described the agency house in great detail:

The agency house was a two-room building situated at the foot of the bluff on which the fort stood and in the fort's east garden where fruit trees and arbor vines grew. Over the years briar roses slowly climbed its walls and chimney, blending it with its verdant surroundings. A brass knocker and metal plate inscribed "United States Agency" were affixed to the front door of the building, which served doubly as office and home.

Near the agency house he planted a garden which provided fresh produce during the summer and by the mid-twenties he also had a few fruit trees. Supplementing the fruit and vegetables were the wild berries and nuts abundant on the island. The environment also furnished game, waterfowl, fish, maple syrup and maple sugar. Some of these foodstuffs were obtained in trade with the Indians.

Early in his career as Mackinac's Indian agent, Boyd was tasked with following a new federal policy to prevent the Anishinaabeks from visiting the British on nearby Drummond Island, where they received annual payment of annuities. Had Territorial Governor Cass's request for a larger army not been denied, soldiers would have implemented the policy by force. Alone, George Boyd was authorized to withhold provisions and presents and to deliver a veiled threat to the Anishinaabeks that their refusal to conform would be met with violence. He visited the various tribes to implore them to consider America their friend and, with no proof, tried to convince them that the British were liars.

Yet, as reported by Humins, Boyd coupled humane treatment with force to gain the Anishinaabeks' confidence in order to implement the policy:

In the attempt to secure their confidence as well as serve their welfare, a good agent was mindful of the health of the native peoples.…During Boyd's years as an agent, small-pox, cholera, and measles swept through the natives under his supervision. Hundreds died because of the contagions.… Throughout most of his years as an agent he succeeded in obtaining the services of a doctor, usually the surgeon assigned to the nearby garrison, to administer to the serious needs of the Indians. Surgeons employed by him normally received $100 a year from the Indian Office.…Boyd's concern was so great at times that he personally tended to the needs of the Indians and furnished medicines from his own cabinet. He explained that he could not "see one of these poor people die before [my] *door, for the want of a little advice or medicine."*

George Boyd petitioned John C. Calhoun, the secretary of war, to increase the $800 allocated to provide presents and provisions, as well as ceremonial flags and medals, to thousands of Indians in his care, but Calhoun denied his request.

George Boyd continued to butt heads with the government, the Anishinaabeks and even some of this own staff (including an interpreter

named John Tanner who was accused of attempted murder in Detroit) until transferred to Green Bay in the Wisconsin Territory in 1832. Unfortunately, later that year, Boyd's son Joshua was killed by an Indian who accused him of cheating him in a fur trade.

Henry Rowe Schoolcraft arrived in Mackinac aboard the schooner *Mariner* at the end of May 1833, fully prepared for duty, having served as Indian agent for ten years in Sault Ste. Marie and armed with a working knowledge of the Ojibwe language, which he learned from his wife, Jane, the daughter of an Ojibwe chief. Ever the conscientious diarist, he recorded in his memoirs that his wife suffered seasickness on the journey to Mackinac:

> *As soon as it could be done, I took Mrs. S. and the children and servants in the ship's yawl, and we soon stood on terra firma and found ourselves at ease in the rural and picturesque grounds and domicil* [sic] *of the U.S Agency, overhung, as it is, by impending cliffs, and commanding one of the most pleasing and captivating view of lake scenery.*

For months, Schoolcraft conducted what he referred to as "my traditionary inquiries," or interviews with Anishinaabek people, listening to their stories and providing them with home-cooked meals, all while reinforcing the fact that their land now belonged to the U.S. government. Between interviews, he observed the Aurora Borealis in the night sky above Michilimackinac and published an essay on the influence of Christianity on North American Indians, their superstitions, the Satanic influence of a particular Ottawa chief and the barbarism of the Chippewa language in describing God. During the first winter, when few visitors could reach the island, Schoolcraft busied himself reading books about geology, recording temperatures and measuring "the tempests of snow, rain and hail." In January 1834, when a few Anishinaabeks visited his office, he distributed one loaf of bread to each, one plug of tobacco to every adult male and some clothing to the elderly and disabled. In February, he wrote a letter to the War Department on behalf of members of a tribe who complained that they did not receive compensation for wood cut for the use of steamboats.

As the weather turned warmer, Schoolcraft planted (or rather supervised the planting of) plum trees, cherry trees, flowers, vegetables, ornamental shrubs, pie plants (rhubarb), fields of clover, timothy grass and oats. Ever the constant gardener, Schoolcraft killed his pet deer, Nimmi, because the animal ate the leaves of fruit trees he planted (as well as from the fruit trees in other people's gardens the deer found while roaming free around the island),

noting in his memoirs, "Poor Nimmi, some are hanged for being thieves. But thou, poor beast! Was killed for eating leaves."

Conscious of his duty to prevent the imbibing of liquor in Indian country, Schoolcraft commanded that a fur trader intent on departing the island with a barrel of whiskey return it to the American Fur Company store where he had purchased it. The clerk told the fur trader, "Mr. Schoolcraft has no authority to prevent your taking it!" Schoolcraft replied, "The moment, in fact, the boats leave the island they enter the Indian country, where the act [federal law] provides that this article shall not be taken on any pretence [*sic*]."

Schoolcraft discouraged a party of Ottawas from visiting Canada with a gentle but firm warning:

> *I told a party of Ottawas, who applied for food, that their Great Father was not pleased that his bounties should be missed by their employing them merely to further their journeys to foreign agencies, where the counsel they got were such as he could not approve. That hereafter such bounties must not be expected.*

Schoolcraft hemmed and hawed over whether to write a book of Chippewa legends in their original form or polished prose. He corresponded with Washington Irving, the celebrated author of *Rip Van Winkle* and *The Legend of Sleepy Hollow*, perhaps hoping that Mr. Irving would help edit the manuscript; however, Mr. Irving claimed little knowledge of Indian tribes but said that he would welcome further correspondence from Mr. Schoolcraft. Dr. Julius of Prussia showed an interest in Schoolcraft's writing when he visited him in Mackinac and remarked on the strong resemblance Indians "bore in features and manners to the Asiatics."

As the number of white visitors to the island increased, Schoolcraft became aware of the increased value of Indian land, as he wrote in his diary:

> *The great lakes can no longer be regarded as solitary seas, where the Indian war-whoop has alone for many uncounted centuries startled its echoes. The Eastern World seems to be alive and round up to the value of the West.*
>
> *The rage for investment in lands was now manifest in every visitor that came from the East to the West. Everybody, more or less, yielded to it.*
>
> *Among other plans, an opinion arose that Michilimackinack must become a favorite watering place, or refuge for the opulent and invalids during the summer; and lots were eagerly bought up from Detroit and Chicago.*

In March 1836, Schoolcraft signed a treaty in which the Ottawa and Ojibwe tribes ceded an area of 13,837,207 acres in the northwest portion of the Lower Peninsula and the eastern portion of the Upper Peninsula in exchange for permanent access to natural resources, including hunting and fishing rights. In 1838, the Indian Dormitory was built by the government for use by leaders of these tribes on their annual visits; however, it was seldom used, as they preferred to camp with members of their tribes along the shores of Mackinac. The Mackinac State Historic Parks website published the sad results of the treaty in an article titled "How Michigan Became a State: The Treaty of Washington, 1836":

> *Unfortunately, Congress altered the terms of the treaty after the Odawa and Ojibway representatives left Washington. Instead of permanent rights to the ceded land, the Anishinaabek found that the final treaty guaranteed them only five years before the government could consider forcibly removing them from northern Michigan. Schoolcraft endorsed removal only two years after the treaty was signed. The Odawa and Ojibway successfully fought against removal, and secured their claims in northern Michigan through the 1855 Treaty of Detroit. More recently, tribal fishermen called upon the provisions of the Treaty of Washington to protect their traditional fishing rights on the Great Lakes.*
>
> *The area ceded to the U.S. government by the 1836 Treaty of Washington represents almost 40% of the current land area of the state of Michigan. Without this land, the Michigan Territory could not have been granted statehood and admitted to the Union.*

A political appointee, Henry Rowe Schoolcraft lost his position as Indian agent with the election of William Henry Harrison in 1841 and was replaced by the American Fur Company's Robert Stuart, who served until 1845. The Schoolcraft family moved east, where Mrs. Schoolcraft, often in poor health and saddened by moving away from her family, died the following year. Over the next few decades, the Mackinac Indian Agency's authority waned as the government became less interested in "civilizing" Indians and more interested in removing tribes from their land.

NATIONAL PARK

In 1875, President Ulysses S. Grant signed into law the bill that created the Mackinac National Park for the "health, comfort and pleasure, [and] for the benefit and enjoyment of the people," declaring Mackinac the nation's second national park three years after he set aside portions of the territories of Montana and Wyoming to create the nation's first national park.

With more than 2.2 million acres of preserved land on the books (Mackinac National Park contributed less than 1,000 acres to the total), the federal government put the creation of more national parks on the back burner until John Muir advocated for Yosemite in 1890.

Wisely, President Grant placed Yellowstone National Park under the control of Columbus Delano, the former rancher and lawyer who served as the secretary of the interior, the department charged with preservation of the nation's natural sources since 1849, yet he placed Mackinac National Park under the direction of the secretary of the War Department, retired general William Belknap, a politician so corrupt that the House of Representatives impeached him with the charge of "criminally disregarding his duty as Secretary of War and basely prostituting his high office to his lust for private gain." According to the U.S. Senate website, "[J]ust minutes before the House of Representatives was scheduled to vote on articles of impeachment, Belknap raced to the White House, handed Grant his resignation, and burst into tears."

Major Alfred L. Hough, post commander and by default Mackinac National Park superintendent, questioned whether he had legal authority over Mackinac Island's civilian population. "What will be done with persons not under military authority who may commit offenses in Mackinac Park?" Nonetheless, Mackinac National Park developed the following "Rules and Regulations," as recalled in *Annals of Fort Mackinac* by Dwight Kelton:

I. Mackinac Park will be under the immediate control and management of the commanding-officer of Fort Mackinac, who is charged with the duty of preserving order, protecting the public property therein, and enforcing these rules:

II. All tenants renting under the Act of Congress providing therefor must conform to, and abide by, such rules and regulations as are prescribed for the care of the park, and will be held responsible for compliance with the same on the park of the members of their families their agents, and employes [sic].

III. The sale of wines and malt or spirituous liquors in the park, without special authority from the commanding-officer of Fort Mackinac, or higher military authority, is prohibited.

IV. No person shall put cattle, swine, horses or other animals on the park, as follows:

The cows belonging to the residents of the Island of Mackinac may be placed in a herd, under the care of a herder, and be permitted to graze in such parts of the park as may be designated by the commanding-officer of Fort Mackinac.

V. Racing or riding and driving at great speed is prohibited.

VI. No person shall commit any obscene or indecent act in the park.

VIII. No frays, quarrels, or disorders of any kind will be permitted in the park.

IX. No person shall carry or discharge fire-arms in the park.

X. No Person shall injure or deface the trees, shrubs, turf, natural curiosities, or any of the buildings, fences, bridges or other structures within the park.

XI. No person shall injure, deface or destroy any notices, rules or regulations for the government of the park, posted or in any other manner permanently fixed, by order or permission of the authorities of the park.

XII. No person shall wantonly destroy any game or fish within the park, nor capture nor destroy the same for any purposes of use or profit.

XIII. Any person who shall violate any of the Rules and Regulations shall be ejected from the park by military authority, and in case the person so offending shall have committed any offence in violation of any of the statutes of the United States, or of the State of Michigan the offender shall be proceeded against before the United States or State courts, according to the laws providing for the same.

XIV. The commanding-officer of Fort Mackinac may, at any time, add to or modify these Rules, subject to the approval of the Secretary of War.

Above: Under the rules of the Mackinac National Park, the commanding officer of Fort Mackinac required islanders to keep their cows in herds under the care of a herder. *Library of Congress, det4a18489//hdl.loc. gov/loc.pnp/det.4a18489.*

Left: Dr. John Bailey petitioned Abraham Lincoln's son to appoint an independent park superintendent to deal with the tourists, who were destroying the island's "natural curiosities." *From* The Annals of Fort Mackinac *by Dwight H. Kelton.*

ESTABLISHED 1845.

JOHN R. BAILEY,

DEALER IN

DRUGS & MEDICINES

TOILET ARTICLES,

And all other Goods usually found in a First-Class Drug Store.

"ANNALS OF FORT MACKINAC,"

BOOKS, STATIONERY,

GUIDE-BOOKS, MAPS, CHARTS, ETC.

Pure Wines and Liquors for Medicinal Purposes.

PRESCRIPTIONS CAREFULLY COMPOUNDED.

DR. JOHN R. BAILEY,

U. S. Examining Surgeon,

(Late Surgeon U. S. Vols., late Attending-Surgeon at Fort Mackinac,)

RESIDENCE, adjoining ISLAND HOUSE. OFFICE, IN DRUG STORE.

The Mackinac Island State Parks Commission dynamited Scott's Cave sometime after World War II to provide rock for road repair. *Michigan State Historic Parks Collection.*

By 1884, the jobs of park superintendent and post commander had become unsustainable due to the number of tourists who climbed over the park's "natural curiosities," motivating Mackinac Island physician Dr. John Bailey to petition Abraham Lincoln's son, Secretary of War Robert Lincoln, to appoint an independent park superintendent.

Ten years later, rumors circulated on Mackinac Island that the federal government favored selling the land to real estate developers. Secretary of War Daniel S. Lamont was of the opinion that Mackinac National Park existed for the sake of wealthy tourists, setting aside the issue of preserving Mackinac's unique "natural curiosities" for the public to enjoy.

Under political pressure from Mackinac Islanders and with the approval of Michigan governor John Rich, both Mackinac National Park and Fort Mackinac were turned over to the State of Michigan and became Michigan's first state park.

MILITARY LAW

The U.S. Army had authority over visitors to Mackinac National Park and the power "of restraining and ejecting offenders not subject to military law." Frustrated by having to command the military and supervise a national park, Captain Greenleaf A. Goodale reported that civilians took birch bark as souvenirs—"nearly every white-birch tree near the park roads has been stripped of its outer bark up to the lower limbs." Because the captain had authority to prosecute civilians who violated Regulation X, which read in part, "No Person shall injure or deface the trees, shrubs, turf, natural curiosities," he ordered soldiers to patrol Mackinac National Park on horseback to apprehend birch bark strippers, as well as tourists who chipped off pieces of Sugar Loaf and Arch Rock. Stripping birch trees was still a problem some twenty years later, when the State of Michigan took over control of the park, prompting the Michigan legislature to enact a law that specifically included removal of bark as a crime punishable by fine or imprisonment (emphasis added):

> *Section 5. Any person who shall wilfully* [sic] *cut,* peel *or otherwise injure or destroy any tree standing in Mackinac Island State Park.…* [S]*hall be fined not less than ten dollars nor more than fifty dollars, or by imprisonment in the county jail of Mackinac county, for a period of not less than ten days nor more than sixty days, or both such fine and imprisonment, at the discretion of the court.*

Visitors were not the only civilians found in violation of military rule: residents chopped trees for the logs they needed to heat their homes during Mackinac Island's brutal winters. Army personnel distributed handbills advising residents that the penalty for cutting wood in Mackinac National Park was "a one-year prison term and a fine of $500.00." When trees were cut down so that visitors could view the park's "natural curiosities" without leaving their rented carriages, Secretary of War Robert Lincoln demanded that all future changes to the park's natural features had to meet the approval of the War Department. Stray cows found in Mackinac National Park were sent to a pound and owners threatened with fines. One day, Lieutenant Woodbridge Geary and armed soldiers apprehended civilians loading gravel onto a schooner.

Members of the military faced imprisonment and fines according to a code older than Fort Mackinac. In 1776, John Adams kvetched about his

The Fort Mackinac commander could not keep up with tourists, who endangered the birch trees on Mackinac Island by stripping souvenirs from the trees, compelling the Michigan legislature to enact a law that made removal of birch bark a crime punishable by fine or imprisonment. *Library of Congress, det4a13076//hdl.loc.gov/loc.pnp/det.4a13076.*

job as chairman of the Board of War, created Congress to combine the military forces of each colony into one body and draft the Articles of War, a document to govern the U.S. Army (emphasis added):

The duties of this board kept me in continual employment, not to say drudgery *from this 12 of June 1776 till the eleventh of November 1777 when I left Congress forever. Not only my mornings and evenings were filled up with the crowd of business before the board, but a great part of my time in Congress was engaged in making, explaining, and justifying our reports and proceedings....I don't believe there is one of them* [lawyers in the United States] *who goes through so much business…as I did for a year and a half nearly, that I was loaded with that office.* Other gentlemen attended as they pleased, but as I was chairman…I must never be absent.

John even complained in a September 22, 1776 letter to his wife about the Articles of War (and the post office):

We have at last agreed upon a plan for forming a regular army. We have offered twenty dollars and a hundred acres of land to every man who will inlist [sic] *during the war. And a new set of articles of war are agreed on. I will send you, if I can, a copy of these resolutions and regulations.*

I am at a loss what to write. News we have not. Congress seems to be forgotten by the armies. We are most unfaithfully served in the Post Office, as well as many other offices, civil and military. Unfaithfulness in publick [sic] *stations is deeply criminal. But there is no encouragement to be faithful. Neither profit, nor honour, nor applause is acquired by faithfulness. But I know by what. There is too much corruption even in this infant age of our Republick* [sic]. *Virtue is not in fashion; vice is not infamous.*

After much debate and compromise, the Articles of War were finalized and later amended in 1806 and governed soldiers posted to Fort Mackinac through the 1890s. Under the Articles of War, penalties ranged from a fine of "one-sixth of a dollar" for behaving "indecently or irreverently at any place of divine worship" to death for more serious crimes, including causing or joining in a mutiny or sedition or not reporting such as plans; threatening violence against an officer; desertion (amended in 1830 to reduce punishment of desertion in peacetime) or persuading another soldier to desert; sleeping while on guard duty or leaving before the end

of shift; causing a false alarm by "discharging of fire-arms, drawing of swords, [or] beating of drums"; committing violence against a person bringing supplies to the fort; misbehaving before the enemy; running away, shamefully abandoning fort or post; casting away arms or ammunition; revealing a secret password; protecting the enemy; supplying the enemy with food, money or ammunition; corresponding or otherwise giving information to the enemy; leaving in search of plunder; or forcing a fort commander to give up or abandon the fort. The maximum number of lashes administered as punishment for some offenses was reduced from one hundred to fifty in 1812, and flogging was abolished during the Civil War.

Under Article 45 of the Articles of War, commissioned officers found drunk on duty could be cashiered (stripped of rank), while noncommissioned officers and soldiers were subject to corporal punishment. At Fort Mackinac, a captain who faced multiple charges of drunkenness had the good fortune of representation by an attorney who argued that the man was highly strung but at all times sober. The captain was acquitted; however, three others received guilty verdicts: two privates charged with drunkenness were forced to carry heavy weights in their backpacks, while a third private found drunk on multiple occasions was punished with fines, thirty days of hard labor, dishonorable discharge and a one-year prison sentence. A cook found drunk shortly after arriving at Fort Mackinac was given a fine of $2.50; however, failing to abide by the rules, he received a $30 fine and three months of hard labor for subsequent offenses, including showing disrespect for a superior officer, punishable under Article 62.

In the summer of 1889, Private John Baseler was confined in the fort prison as punishment for his "unruliness"; however, due to the compassionate nature of Post Captain Greenleaf A. Goodale, John was allowed to leave the prison to pray at the deathbed of his three-year-old daughter, Lena. Lena Baseler died soon after and was buried at the Fort Mackinac Post Cemetery.

Deserters faced serious consequences under Article 57:

> *Any person subject to military law who deserts or attempts to desert the service of the United States shall, if the offense be committed in time of war or when under orders for active service when war is imminent, suffer death or such other punishment as a court-martial may direct, and, if the offense be committed at any other time, any punishment, excepting death, that a court-martial may direct.*

No deserters were sentenced to death at Fort Mackinac, and many simply left the island and were never apprehended. Among these deserters was Private Charles Mahar, who abandoned his wife and newborn daughter, Rosetta, who died shortly after her first birthday and was buried at St. Ann's Cemetery. The private escaped over the ice to Cheboygan, where he was apprehended and sentenced to prison.

POLITICAL PRISONERS

Brian Jaeschke, register for Mackinac State Historic Parks, shed light on a little-known chapter of Fort Mackinac's involvement in the Civil War. Although no Civil War battles were fought at Fort Mackinac, nor anywhere else in the state of Michigan, in 1862 Fort Mackinac received three prisoners from Tennessee who refused to swear allegiance to the U.S. government.

This is the loyalty oath that Military Governor of Tennessee and future president Andrew Johnson administered to Confederate sympathizers:

> *I do solemnly swear that I will support, protect and defend the Constitution and Government of the United States, against all enemies, whether domestic or foreign, and that I will bear true faith, allegiance and loyalty to the same, any law, ordinance, resolution or conviction to the contrary notwithstanding; and further: that I do this with a full determination, pledge and purpose without any mental reservation or evasion whatsoever; and further: that I will well and faithfully perform all the duties which may be required of me by law.*

The prisoners were already on their way from Nashville; however, Fort Mackinac was not ready to receive them and did not want them. In fact, a few months earlier, a request to fill the nearly abandoned fort with prisoners was declined. In the words of Mr. Jaeschke, "Mackinac's remote location as well as a lack of troops to act as guards and the existence of other military prisons, may have precluded sending prisoners there early in the war."

Nonetheless, in May 1862, the *Detroit Free Press* reported that the Stanton Guards, along with limited rations, were headed to Mackinac Island aboard the steamship *Illinois*—a comfortable ship, advertised in that newspaper as "the favorite side-wheel steamer." A travel writer for the newspaper lamented that day-trippers visiting points of interest on the island were not allowed to

have a gander at the prisoners, housed temporarily in a hotel while Captain Wormer of the Stanton Guards awaited the arrival of new furniture for the comfort of the prisoners. With good accommodations and freedom to wander through town, the three prisoners made no complaints and did not attempt to escape. But by September, the prisoners and their guards had left Fort Mackinac for Detroit. Two of the prisoners had a change of heart and swore allegiance to the United States and were paroled, while the third prisoner was sent to a military prison on Lake Erie.

CIVIL LAWS

Current laws, officially the Code of Ordinances of the City of Mackinac Island, Michigan, rest on a stack of lost laws—obsolete, outdated and sometimes distinctly peculiar. For example, under the laws of the Michigan Territory, which governed the island until the establishment of the State of Michigan in 1837, the borough of Michilimackinac employed "fence viewers" who roamed the island looking for "beasts" that damaged fences, collected fines from the beasts' owners and destroyed or sold unclaimed "beasts." The governor of the Michigan Territory appointed the hard-nosed military man William Henry Puthuff as mayor. Territorial laws granted Michilimackinac officials the power to collect a ten-dollar license fee to operate "ordinaries" (an archaic British term meaning inns that provided meals at fixed prices). To prevent fires from breaking out in wooden buildings downtown, the borough passed an ordinance requiring chimneys to be swept clean every two weeks and that if fire should break out, every able-bodied male was required to help or be subject to a fine of ten dollars. The laws governing the fence viewers and ordinaries (as well as hundreds of other laws) were lost with the establishment of the State of Michigan.

When members of the Michigan legislature dissolved the borough of Michilimackinac and incorporated the village of Mackinac, they promised that the village would survive *forever*. The Act to Incorporate the Village of Mackinac, approved on March 25, 1848, reads in part (emphasis added):

> *That all the citizens of this state, inhabitants of the island of Michilimackinac, be, and the same are hereby ordained, constituted and declared to be, from time to time* forever *hereafter, one body corporate and politic in fact and in name, by the name of "the president, trustees and*

citizens of the village of Mackinac," and by that name they and their successors forever *shall and may have perpetual succession.*

Under these laws, the village of Mackinac was granted powers "relative to the sweeping of chimneys"; relative to restraining horses, cattle, sheep, swine or any geese from going at large within the limits of said village; to "levy taxes on polls"; to inspect "any kinds of fruit brought to said village for sale or exportation"; and to provide penalties of up to twenty-five dollars per offense. Then there was the problem of stinky dead fish. According to Phil Porter, the author of *Mackinac an Island Famous in These Regions*:

> *Local fishermen created an unsightly and smelly refuse problem for the village. Reacting to the growing piles of fish guts scattered along the island shore, the village council outlawed the dumping of "fish remains" on city streets in 1848. Five years later they prohibited the "cleaning and dressing" of fish on the lakeshore within the city limits and restricting the dumping of "fish offal" to an open field beyond the western edge of town.*

Yet despite the promise of the Michigan state legislature, nothing is forever. Goodbye, village of Mackinac. Hello, city of Mackinac Island. Poll taxes, fruit inspection, fence viewers and other laws were lost, along with the Village of Mackinac and Holmes Township, in 1899, when the state established the City of Mackinac Island. From the City of Mackinac Island website: "The City Charter was passed by the State of Michigan Legislature in 1899 which vacated the Township of Holmes and Village of Mackinac to incorporate the City of Mackinac Island." It continued:

> *The People of the State of Michigan enact: That from and after March twentieth, A.D. nineteen hundred, the township of Holmes and Village of Mackinac in Mackinac County, and State of Michigan, shall be and are hereby vacated, and all the territory now comprising the said Township of Holmes and Village of Mackinac, the same being all of Mackinac Island and Round Island, in said Mackinac County, shall be and the same is hereby constituted and declared thereafter to be a city corporate by the name of the City of Mackinac Island, by which name it shall thereafter be known, and the jurisdiction of said city shall embrace and covert the navigable waters adjacent to said city for the distance of one mile from the shorelines of said islands.*

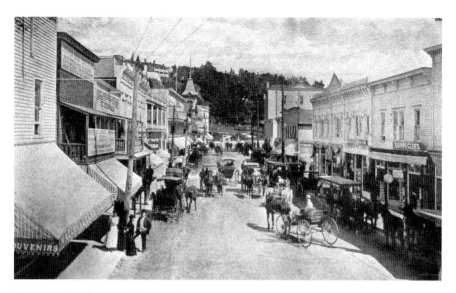

Large, overhanging canopies are no longer permitted downtown. *From* Historic Mackinac *by Edwin Orin Wood.*

The general powers of the newly incorporated city included the authority to punish beggars and drunkards, prohibit houses of ill-repute, require all businesses to be closed on Sundays, prohibit the use of sling shots, prescribe the time for opening and closing of stores and determine the type articles that may be sold. The Municipal Code of the City of Mackinac Island continues to evolve as the city faces news challenges, replacing obsolete laws with laws relevant to today.

LOST VESSELS

LIGHTSHIPS

While serving as secretary of the U.S. Treasury, Alexander Hamilton concocted a brilliant idea for the Revenue Marine, which ultimately led to legislation that placed men in small wooden boats anchored in the Straits of Mackinac. Hamilton's Revenue Marine, which thwarted smugglers and collected tariffs along the Eastern Seaboard, expanded its mission to encompass assisting marine navigation. Where lighthouses were needed but could not be built safely, small wooden ships lit up the dangerous waters. As Hamilton's Revenue Marine morphed into the Revenue Cutter Service and ultimately the U.S. Coast Guard, four ships were assigned to the Straits of Mackinac.

WAUGOSHANCE SHOAL (1832–1851)

On May 26, 1831, the *Detroit Free Press* published a detailed proposal for a lightship destined to be moored at the head of the strait connecting Lakes Huron and Michigan. The ship's plan included "beams of yellow heart pine, free from sap," "a trunk cabin fitted for the accommodation of six persons, with births, lockers, cupboard, etc.," "a bell of four hundred pounds" and "one cast iron mushroom anchor, of eight hundred pounds." Collector of

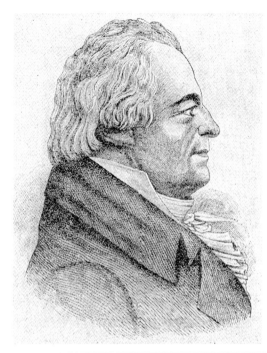

Left: Alexander Hamilton's Revenue Marine morphed into the Revenue Cutter Service and ultimately the U.S. Coast Guard, with ships that protect the Straits of Mackinac. *From* Early Mackinac *by Meade C. Williams.*

Below: Deemed unsuitable for the Straits of Mackinac, the lightship *Louis McLane* nevertheless was assigned to protect vessels from danger at Waugoshance Shoal. *From the collection of Herman C. Chapman, master model boat builder.*

Customs Adam Duncan Steuart cautioned, "All materials to be of the best quality and the vessel with her fixtures finished in the most complete and workmanlike manner, by the first day of May, 1832. No payment will be made until the whole of the above work shall be completed and approved."

But according to Scott Bundschuh, author of *Lightships: Keeping Watch Over the Great Lakes*, the U.S. Treasury decided to economize by choosing a used boat outfitted with a lantern and an iron triangle (the type shown in western movies to summon cowboys to dinner) to warn ships of hazards. Unfortunately, the quickly refurbished *Louis McLane* was not suitable for the dangerous conditions of the Straits of Mackinac.

Problems plagued the lightship almost immediately. On January 28, 1835, the *Democratic Free Press* reported that the legislative council of the Michigan Territory related to Congress:

> *That light vessel was built two or three years since, and stationed near point Waugoshanee, in the strait which connects Lake Michigan and Lake Huron. That she has several times, either from the high winds or the heavy seas which roll in the strait from Lake Michigan, been driven from her mooring, and compelled to leave the strait. This uncertainty in her station but increases the difficulties of the navigation; for in heavy gales, or when the weather is foggy, the mariner can never approach the reef of rocks with any confidence that he will either see her light or hear her bell.*

In November 1837, a violent storm that raged for four days blew the *Louis McLane* off course, forcing the crew to abandon ship in a lifeboat, leaving behind their personal belongings. The cold, water-logged sailors were saved, but the lightship continued rushing through icy waters that battered its hull and ripped it sails. Captain Keith reported a loss of personal property worth $200 and declared the *Louis McLane* a miserable model unable to navigate angry gales.

In their book *Lightships of the Great Lakes*, authors Larry and Patricia Wright reported that U.S. Lighthouse Inspector Homan stated the *Louis McLane* was "better employed near the more sheltered flats of Lake St. Clair" and recommended that "another [light vessel] be immediately built upon a more approved model for the straits, so as to be ready for removal there on the opening of navigation in the spring. The dangers of large commerce passing through these straits are great from the extensive shoals, that of Waugoshance Shoal, in particular, and demand the safeguard of the lightvessel that may be relied on at the point most desirable."

Nevertheless, the *Louis McLane* was repaired and returned to the site the following year, but in 1844, when another ship, the secondhand schooner called *Ocean*, arrived at Waugoshance Shoal, the *Louis McLane* was towed to Detroit for repairs and then reassigned to the Detroit River.

After three years of duty, the *Ocean* was so severely damaged that a summer rental was brought to the shoal while repairs were made. Owners of the trading schooner *Madeline* charged the U.S. government $450 for the summer. After the *Ocean* returned to duty, the *Madeline* went back to transporting cargo and ferrying Mormons to Beaver Island. Two years later, the *Ocean* failed to prevent the collision of the *S.F. Gale* and the *Miranda*.

The era of lightships at Waugoshance Shoal ended in 1851 with construction of the Waugoshance Lighthouse. But improved lighting and hazard warnings could not tame the dangerous straits. In 1858, the *Island Queen*, filled with lumber destined for Chicago, ran ashore on Bois Blanc Island; the following year, the schooner, with a cargo of wheat destined for Chicago, blew off course and ended up at Waugoshance Point. Ten years later, the *Dolphin* collided with the *Badger State*, quickly sinking at Waugoshance Point within twenty minutes. Fortunately, the crew was pulled from the water and brought to Mackinac City. The Waugoshance Lighthouse was deactivated in 1912 and used by the U.S. Navy for bombing practice during World War II.

WHITE SHOAL LIGHTSHIP (1878–1909)

Ships smashed against this long, barely submerged shoal for nearly half a century before the government sent a lightship in 1891. One spectacular shipwreck was reported by newspapers around the country in December 1860. Initially, the *Cleveland Daily Leader* announced the loss of the schooner *Circassian* and its crew, but the inaccurate report was corrected by the *Ashtabula Weekly Telegraph* on December 15, 1860:

> *On Thursday last the crew of the schooner* Circassian *arrived at home, to the great relief of the friends of the parties. We learn that the* Circassian *went onto the White Shoals at 11 o'clock Thursday night November 22nd, during a violent snow storm—twenty-four hours before the storm, was felt on the lake. The wind was blowing hard, and every sea making a clean breach over the vessel as she lay pounding upon the rocks. The small boat*

was let down and hauled round to the bow of the vessel and kept there during the night—the crew remaining forward during the night, wet and cold. Soon after striking, the vessel broke in two amidships. At daylight the small boat was hauled along side and the crew embarked, without saving any of their effects except those of the captain's, which had been secured on the vessel first striking. They went off before the wind and landed on the main shore some fifteen miles below the wreck. After hauling their boat up they had to travel through deep snow, the bitter piercing wind freezing their drenched garments. With difficulty they reached a fisherman's hut, where relief was at once afforded. Their escape was fortunate, for six hours after leaving the wreck, the vessel went to pieces and the sea was so violent that no small boat could have survived any length of time.

In their book *Shipwrecks of the Straits of Mackinac*, authors Charles and Jeri Feltner described how the captain and crew rowed to Hog Island and walked for two miles to reach the fisherman's hut, adding, "The *Circassian* had been purchased by William Mashburn of Chicago on the very day she departed on her fatal voyage."

In 1866, Ohio shipbuilder Winfield S. Lyons put his eponymous schooner to work transporting iron ore in the Great Lakes, where it operated without major incident for five years until a gale pushed it aground at White Shoal. The salvage tug *Magnet* tried to push the *W.S. Lyons* back on course, but the schooner's massive cargo kept the *W.S. Lyons* in situ. The *Magnet* was pressed into service rescuing other stranded ships, but the saga of the *W.S. Lyons* wasn't over quite yet. The *Magnet* returned to remove the schooner's masts, rigging and anchors before a second gale sank the ship in October 1871.

Without waiting for the federal government to prevent further disasters, owners of the Chicago Lumbering Company stationed and maintained its own homemade lightship at White Shoal from 1878 to 1891.

Congressmen lobbied for a lightship at White Shoal, and with some difficulty, *LV 56* reported for duty. Authors Larry and Patricia Wright chronicled problems that began almost immediately:

LV 56 was turned over to the Lighthouse Establishment at Detroit in mid September, 1891. When they conducted sea trials they noted many defects. After making necessary repairs LV 56 was moved on October 19, partly under its own power and partly under two by the lighthouse tender Dahlia, *along with LV 55 and LV 57. While heading to stations in northern Lake Michigan, the vessels ran into heavy weather and had to seek shelter*

behind the breakwater at Sand Beach Harbor, along with 90 other vessels. By October 23 the weather was calm enough for them to continue on their way. The State of the art, LV 56 *was self-propelled, equipped with three oil-burning lanterns, a steam whistle and eventually a brass fog bell.*

Steamer *William H. Barnum* left Chicago on April 1, 1894, with a cargo of corn destined for Port Huron. The ship arrived at White Shoal ahead of schedule, but icy waters in the straits battered the twenty-year-old ship; Captain Smith's efforts to patch holes were to no avail. The tug *Crusader* rescued the crew, and a Canadian company purchased the waterlogged corn to manufacture starch to stiffen ladies' lingerie.

On September 6, 1898, readers of the *Detroit Free Press* woke up to news of a dramatic shipwreck at White Shoal. "WENT TO THE BOTTOM" blared the headline, followed by subheadings "SCHOONER *WINSLOW* SANK IN THE STRAITS YESTERDAY MORNING. SHE LABORED HEAVILY IN A LIVING GALE. WATER POURED INTO HER HOLD AND SHE BECAME UNMANAGEABLE. STEAMER INTER-OCEAN MADE A DARING RESCUE OF THE CREW. HEAVY SEA WAS RUNNING, BUT ALL THE MEN WERE TAKEN OFF."

Fortunately, the crew was safe, and the schooner and its 1,600-ton cargo of iron ore were heavily insured. Because the partly submerged wreck posed a hazard to ships in the waters of White Shoal, the U.S. Army Corps of Engineers flattened it with dynamite a few years later.

For more than twenty-one years, the steamer *Eber Ward*, named for the keeper of the Bois Blanc Island Lighthouse, carried cargo to ports in the Great Lakes. However, in April 1909, after passing White Shoal, the ship collided with an ice floe, sinking into the icy water within ten minutes of impact. Five crew members were drowned, and a cargo of fifty-five thousand bushels of corn was lost. In its annual report, the Steamboat Inspection Service carried a brief mention of the accident. "While en route from Milwaukee to Port Huron steamer *Eber Ward* collided with heavy ice in the Straits of Mackinac and sunk. Loss $40,000. Five of the crew were drowned. Case was investigated and Timese Lemay, master, was found guilty of misconduct, negligence and inattention to his duties, and his license was revoked."

The federal government maintained lightship *LV 56* at a cost of $4,000 annually until it was replaced by the White Shoal Lighthouse in 1909.

GRAY'S REEF

Funds for a Gray's Reef lightship were raised following a series of shipwrecks, including a pileup in 1889 that left property worth $1 million on Gray's Reef. An Ohio company built Gray's Reef's first lightship, *LV 57* and two sister ships—*LV 55* and *LV 56*—all of which failed Lighthouse Board inspections and could not be delivered on time. After several weeks, the repaired ships were deemed safe, and the convoy headed to the straits, stopping at Sand Beach Harbor to wait out a storm. *LV 57* finally arrived at Gray's Reef on October 24, 1891; however, it didn't stay long. According to a report that appeared in the *Detroit Free Press* on November 21, 1891: "The Grey's [*sic*] Reef lightship left today for Cheboygan contrary to orders which had been delivered by the *Dahlia*. The keeper concluded that he has had enough of Grey's [*sic*] Reef during this last terrific gale."

Consequently, crew members were fired, replaced by another crew, and lightship *LV 57* returned to Gray's Reef. Despite numerous repairs and modifications, *LV 57* served until 1923.

LV 103, which visitors to Port Huron may know as the Huron lightship, was stationed at Gray's Reef from 1924 to 1926 and again in 1929. (Lightship *LV 56* provided relief in the 1927 and 1928 shipping seasons.)

LV 99 was the last lightship stationed at Gray's Reef until the lighthouse was built in 1935.

POE REEF

Shipwrecks befell mariners at Poe Reef for years before installation of a lightship. In 1887, the steamer *Albany* blew distress signals as a gale and heavy snow drove it into Poe Reef, causing damage and forcing the crew to jettison its cargo of flour. In 1891, the steamer *Cumberland*, towing the schooner *Golden Age*, ran into Poe Reef. Later that year, the *New Orleans* ran aground at Poe Reef. In May 1892, the tug *Sweepstakes* attempted to remove the schooner *Annie M. Peterson* from Poe Reef, followed by another attempt by the wrecking tug *Manistique*. In October 1892, the *Pillsbury* and the *Nahant* collided at Poe Reef. As ships crashed into Poe Reef, Chicago's *Inter Ocean* newspaper published the views of Great Lakes ship captains:

> *Many lake captains are in favor of a lightship at Poe's Reef in the Straits of Macinac* [sic]. *They state that with a lightship at that point nearly all*

the danger in entering the straits from Lake Michigan will be averted. There have been several wrecks on that reef this season.

But the people of Detroit argued against placing a lightship at Poe Reef. From the *Buffalo Enquirer*:

They make a point that if a lightship located at Poe's Reef would be of value to everything going to Lake Michigan, a light at Corsica Shoal would benefit almost the entire lake tonnage. It would relieve the Lake Carriers [a trade group representing commercial cargo vessels] *of a part of the expense of maintaining private lights, while the establishment of the lightship at Poe's Reef would only tend to nullify a measure now pending to locate a lighthouse there.*

Despite opposition, on September 29, 1893, *LV62* arrived at Poe Reef in 1893 and remained until the end of the 1910 shipping season, followed by eight years at Bar Point Shoal. A nearly identical lightship, *LV 59*, served at Poe Reef for less than three years. Having been deemed unseaworthy in September 1914, a gas buoy was placed in the water until the end of the shipping season. *LV 96*, built by a Muskegon shipbuilder, served at Poe Reef from 1915 to 1920. Lightship *LV 99* served from 1921 to 1929, when it was replaced by the Poe Reef Lighthouse.

CANOES, SCHOONERS AND STEAMERS

The trip across the straits to Mackinac Island takes only a few minutes thanks to speedy ferries—sip a morning latte, munch fudge on the return, thank the smiling staff for a safe, carefree journey and carry on. But a journey across the straits was not always so easy.

The Anishinaabeks arrived in birch-bark canoes, ingeniously and skillfully crafted by men and women from materials at hand; the canoes were eagerly adapted by French fur traders. These lightweight vessels were designed for slow travel, fishing in a lazy river or carrying goods and furs. Yet birch-bark canoes could meet the fury of angry waves in the straits. They dotted the shores of Michilimackinac for hundreds of years.

A sort of canoe building renaissance over the past few decades led descendants of the first canoe builders to resurrect the birch-bark canoe. As

Lightweight canoes carried heavy loads of furs sold at Mackinac Island. *From* Early Mackinac *by Meade C. Williams.*

Tom Byers, a member of the Pokagon Band of Potawatomi, told the *Petoskey News-Review*:

> [T]*he vessels are an example of what humans can accomplish when they work with nature rather than against it. They're made from renewable resources, don't create pollution when made or used and are completely biodegradable, he said.*
>
> *It has more to do with being connected to the earth and nature than it does a particular cultural tradition or religion of any kind....It is about working with natural materials and making that connection.*

But building a birch-bark canoe in the traditional manner isn't easy. Ron Paquin, an award-winning artist and elder of the Sault Ste. Marie Tribe of Chippewa Indians in Sault Ste. Marie, often uses power tools and lumber purchased from a local mill for the classes he teaches. As far back as the fur trading era, French traders used nails instead of lashings. Nearly a century ago, the Office of Indian Affairs published a thirty-cent pamphlet setting forth the steps to build a birch-bark canoe according to tradition:

The making of a birch bark canoe required much skill. When a canoe was to be built heavy birch bark was collected in the late June or July [when it would peel off most easily] *rolled up and laid away in the shade. Before shaping the canoe strips of white cedar or other straight-grained wood were carefully split and whittled into the required sizes to form the ribs, sheathing, thwarts, and gunwales for the top of the frame, and were placed in the water to render them more flexible. Poles and stick* [sic] *were brought to the proper length by the use of fire.*

All measurements for a canoe are calculated by distances between various parts of the human body. The correct depth of a canoe amidships was the distance between the elbow and thumb. The right distance between the ribs was the span from the little finger to the thumb. Black spruce root was used for measuring.

When canoe was to be started, towards evening, or at any time when the day was cloudy, the bottom pieces of bark were placed in position, overlapping a few inches in the middle where they were to be joined. If a single length of bark was not available, two or three pieces of bark were used as necessary. Stones were laid on the bark to hold it down, and a temporary bottom frame, approximating the width of a canoe at the bottom and pointed at both ends, was then applied. Stakes were driven into the ground nine or more to a side. They were placed at intervals to approximate the length and width of the canoe and were arranged to flare outward slightly.

Up to this point the work was carried on by the men. The next step was performed by the women. They made slashes or gores on each side towards the ends where the cane begins to narrow and sewed them with the fine roots of the spruce, tamarack, or the jack pine. Before using the spruce root for sewing, the women split the fibers to a suitable size and rendered them flexible by steeping them in fish broth.

The men next laid the upper lengths of bark alongside, measured them by trial, then placed them in position. The bottom pieces were then scored along the bottom with an ax where they were to be creased for the taper to bow and stern, after which both the upper and lower barks were pinched together by stakes driven closely and tied at the top An inner frame (or "inside gunwale") giving shape to the upper edge of the canoe and having exactly the right taper and curve, had been prepared beforehand, and was now placed between the upper edges of the bark and sewed closely and firmly to them. Pieces of cedar, bent to the approved shape of bow and stern, were placed between the barks at the ends of the canoe, and the bark

trimmed to conform to those in outline, then sewed to them with spruce root. In all cases the sewing was done by the women. Stitches of uneven length were often employed, particularly around the ends, that prevent the bark from splitting. After being sewed the gores, and laps were well stuck together with a clear spruce gum that had been boiled a little to thicken it. All laps had their outer edges running backwards or towards the stern, so as not to obstruct the motion of the canoe.

The bottom frame, which was merely temporary, was then removed, the ribs taken from the water, bent to shape around the knee, cut to length, and driven into place with a mallet. Other thin strips of cedar, three or four inches wide, were driven between the ribs and bark as the work proceeded, for the purpose of forming a protective flooring and siding. The canoe, particularly at this stage, was well moistened both inside and out. The placing of the ribs and sheeting proceeded, generally speaking, from the ends to the center. Cross pieces, to keep the top spread, were hammered in at every second rib. The ribs were a couple of inches wide and about the same distance apart. When the insertion of the ribs and sheeting had been completed, a general correction was given to the shape of the canoe by tying it between stakes and exposing it for a while to the sun. When the canoe was completed, it was taken from the frame and inverted, preparatory to being gummed with pitch.

By the time the canoe was put together, the women would have the spruce gum ready to gum the seams to make them waterproof. The spruce gum was obtained from trees that had been gashed the year before, boiled a little while to thicken it and mixed with powdered charcoal for ornamental purposes. The bottom seam was coated with clear gum and pegged not sewed. The last step in canoe making was to attach a top gunwale strip by tying or binding it on with spruce root.

A birch bark canoe can be made in from ten days to two weeks if all the materials have been prepared and are at hand. The bark for the covering and sewing, the cedar for the framework, and the pitch for making the canoe watertight all require time in gathering and preparation. While the canoe is under construction definite periods of waiting are necessary for certain parts of the canoe to dry to form. Ordinarily six persons are required to do the work, four of whom are women. The women sew the birth bark together for the covering and the lace the gunwales.

French fur traders developed the bateau, a wooden boat, described by the late historian Carric Westlake Whitney as "a clumsy, flat-bottomed

boat, fifty to seventy-five feet long," propelled "with great difficulty." In comparison to the birch canoe, *Frank Leslie's Popular Monthly* reported that the bateau "was about the same size as the canoes, but made of wood, instead of bark, clumsier, heaver, slower and more awkward." Made of red cedar logs fastened together with iron bolts and wooden pegs, these long boats with high bows and slanted sides required expert navigators to ensure that crew and cargo arrived safe and dry.

Historians Timothy Cochrane and Hawk Tolson credited Native Americans in the development of the Mackinaw boat: "Their technological contributions are part of the misty beginnings of the Mackinaw creation and history." Over time, the term "Mackinaw boat" lost its meaning, as it was used generically to describe any small wooden boat; however, a true Mackinac boat is twenty or more feet in length and has a wooden carvel-built hull, a sharp bow and stern, two masts and a jib, with a centerboard and shallow keel. In an 1872 report, Commissioner of Fish and Fisheries James Milner touted the safety of the Mackinaw boat:

[It] *is fairly fast, the greatest surf-boat known, and with an experienced boatman will ride out any storm, or if necessary, beach with greater safety than any other boat. She is comparatively dry, and her sharp stern prevents the shipment of water aft when running with the sea. They have been longer and more extensively used on the upper lakes than any other boat, and with less loss of life or accident.*

In 1918, Edwin O Wood gave this description of the Mackinaw boat in the second volume of *Historic Mackinac: The Historical, Picturesque and Legendary Features of the Mackinac Country*:

The type of boat known as "Mackinaw" was fairly large, strongly built, flat-bottomed, and pointed at both ends. Its adaptation to ascend and descend easily dangerous rapids suited it especially for the fur trade. With it was used a large sheet of painted or oiled canvas, to cover the merchandise or furs in bad weather.

Mackinaw boats received mixed reviews from passengers. While visiting Mackinac Island in 1850, scientist Louis Agassiz mentioned his experience with a Mackinaw boat in his book *Its Physical Character, Vegetation, and Animals Compared with Those of Other and Similar Regions*:

Famed scientist
Louis Agassiz did not
appreciate the design
of the Mackinaw boat.
*Library of Congress,
cph3a29258//hdl.loc.gov/
loc.pnp/cph.3a29258.*

Rather than wait here a week for the next steamer we engaged a Mackinac boat and some Canadian to take us to the Sault. These boats are a cross between a dory and a mud scow, having something of the shape of a former and something of the clumsiness of the latter. Our craft was to be ready early in the morning, but it was only by dint of scolding that we finally got off at 10 o'clock. A very light breeze from the southward made sufficient excuse to our four lazy oarsmen and lazy skipper for spreading a great square sail and sprit-sail, and lying on their oars. Unless it was dead calm, not a stroke would they row.

Constance Fenimore Woolson immortalized the Mackinaw boat in her tragic poem "Off Thunder Bay," which tells the story of two doomed lovers who sailed on Lake Huron in their boat, *Wing and Wing*. The lovers

were never to be seen again; however, the Mackinaw boat was recovered by the heartbroken parents. Despite Agassiz's critique and Woolson's tragic tale, Mackinaw boats were popular with tourists until the beginning of the twentieth century.

THE WAR OF 1812

Lieutenant Porter Hanks may have guessed that something was up after watching large canoes glide in the straits day after day, but as he hadn't heard anything from the War Department, he slept soundly the night of July 16, 1812, unaware that a letter containing a declaration of war, mailed on June 18, 1812, via regular mail, was on its way and that Native American warrior canoes and the British ship the *Caledonia* were about to land on Mackinac Island. The *Caledonia* began its life in 1807 hauling fur for the North West Company of Canada before the British government requisitioned the brig (a two-masted sailing ship with square rigging on both masts) for the War of 1812. The HMS *Caledonia* was captured by the United States on October 8, 1813, and outfitted with heavy artillery (two long twenty-four-pounder guns and one thirty-two-pounder carronade) and served as the USS *Caledonia* until the navy sold the ship in 1815, at which time it was refitted as a commercial ship and christened with a new name, the *General Wayne*. This ship sank in Lake Erie in the 1830s and was recalled by Toronto journalist Charles Henry Jeremiah Snider eighty years later in his book, *In the Wake of the Eighteentwelvers; Fights & Flights of Frigates & Fore-'n'-Afters in the War of 1812–1815 on the Great Lakes*:

> *If ever vessel felt despair—and who can look a ship in the hawse-pipes* [the gadget that holds the anchor chain in the ship] *and say she does not feel?—it must have been the poor little Caledonia. She had been a fur trader, the North-West Fur Company's brig. Through these waters again and again had she stormed her way, up-bound with a cargo of traders' stores in springtime, homeward-bound, late the fall, deep-laden with costly skins of beaver, otter, fox or bear.* [Then] *her brave red ensign had proudly waved above the troops which surprised Michilimackinac.... And now, with a different flag aloft, and eight cannon cumbering her short, broad deck, she was driving along with a foreign squadron.*

Five-mastered schooner similar to warships of 1812. *Library of Congress, cph3a06395//hdl.loc. gov/loc.pnp/cph.3a06395.*

In the summer of 1814, seven American ships carrying more than seven hundred men sailed from Detroit with the goal of recapturing Mackinac Island from the British, who had seized it two years earlier, landing on the northwest shore. The ships included the following battle-tested warships.

The brig *Lawrence*—built in 1813 under the guidance of Commander Perry and named for Captain James Lawrence, who uttered the famous words "Don't give up the ship!"—measured over one hundred feet long, weighed nearly five hundred tons and carried two long twelve-pounders and eighteen short thirty-two-pounder carronades. Before arriving at Mackinac, the USS *Lawrence* had served as the flagship for Commander Perry in the Battle of Lake Erie and was intentionally sunk in 1815 to preserve the hull. According to the *Somerset Press*, on May 26, 1876, sixty years after the *Lawrence* sank in the aptly named Misery Bay, the ship was resurrected for an exhibit at the World's Fair of 1876. At the conclusion of the fair, plans were made: "It will be cut up and sold for canoes, chairs, etc." Unfortunately, the exhibit caught fire in December 1876, completely destroying the USS *Lawrence*.

The *Niagara*, a brig launched in 1813, played second fiddle to the USS *Lawrence* during the Battle of Lake Erie, serving as a relief ship for Commander Perry when the latter took on heavy fire while proudly displaying a flag bearing the words "Don't Give Up the Ship." The *Niagara* measured 110 feet long, weighed nearly three hundred tons and carried eighteen thirty-two-pounder carronades and two twelve-pounder long guns. From 1815 to 1820, the badly damaged *Niagara* functioned as a receiving ship, the temporary quarters for new recruits, after which, like the *Lawrence*, it was intentionally sunk in Misery Bay to preserve the hull. Plans to rebuild what was left of the *Niagara* were in limbo for decades due to lack of funds; however, through the dogged determination of the Flagship Niagara League, an authentic reproduction is on display at the Erie Maritime Museum.

Stephen Champlin commandeered the schooner *Scorpion* ahead of his cousin Oliver's flagship, *Lawrence*, as they fought the Battle of Lake Erie. A sailor since the age of sixteen, Champlin fired the first shot and the last shot of the battle. Daniel Turner took over as commander of the *Scorpion* in the Battle for Mackinac. The *Scorpion* measured sixty-two feet in length, weighed eighty-seven tons and carried one thirty-two-pounder long gun and one thirty-two-pounder carronade. The British captured the *Scorpion* in September 1814 and rechristened it the HMS *Confiance*, the French word for confidence.

A cruel twist of fate awaited Stephen Champlin at Mackinac, now in command of the *Tigress*, a schooner fifty feet in length, weighing fifty-three tons and carrying a single thirty-two-pounder gun. Not only were he and his crew captured by the British, but the *Tigress* (later to be rechristened the HMS *Surprise*) deceptively flew the American flag and sidled up to the *Scorpion*, capturing the crew and the schooner.

FLOATING PALACES

Post–Civil War prosperity brought tourists to Mackinac, who could enjoy the journey as much as the destination if they could afford passage on luxury steamships accurately dubbed "floating palaces." Imagine walking on staircases "made of white mahogany," dining in a room "like a prince's banquet hall" and gazing at the sun through an "amber-tinted glass" skylight. James Beaven, professor of divinity at King's College, who visited Mackinac

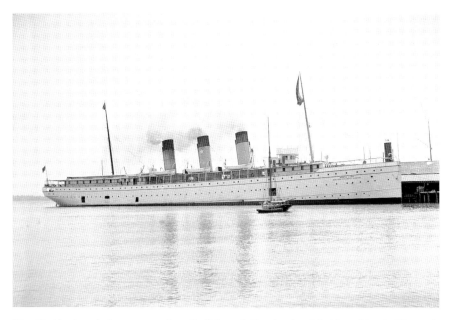

The *Northland* carried passengers from Buffalo and Cleveland to Mackinac Island. *Library of Congress, det4a07884//hdl.loc.gov/loc.pnp/det.4a07884.*

Island before the war, described the steamship *Empire* in his book *Recreations of a Long Vacation*:

> The fittings-up are very handsome....The ladies' or family state-rooms are upon a scale which I never saw before in a steam-boat, with sofas and chairs, and some with little dressing closets; and there are two sets of two rooms each, a bed-room and sitting-room....There were likewise couches in the gentlemen's saloon, a very special article of comfort in this hot climate.

Features described in travel brochures mentioned flush toilets and hot and cold running water—amenities passengers probably didn't even have in their homes. Mark Twain wrote that the steamships destined for Mackinac were more comfortable and pleasant than the side-wheelers he piloted on the Mississippi, saying that the *North Land* "is the best I have ever seen." One steamer destined for Mackinac advertised a dinner menu that included a choice of broiled Lake Superior whitefish, sirloin steak or roast lamb, followed by banana fritters, tiny string beans, new potatoes in cream, pickled beets or tomato salad and a dessert course of cream cheese with jam, cherry pie and ice cream washed down with tea, coffee or milk—all included in the

The Route of all Others for Tourists and Others
➤➤ IS BY THE ◄◄

Traverse×City,+Petoskey

🚂 MACKINAC

DAILY LINE OF STEAMERS

FORMED BY THE FINE PLEASURE STEAMERS

"CITY OF GRAND RAPIDS" and "T. S. FAXON."

ONE of these Steamers leaving MACKINAC and the other TRAVERSE CITY, EVERY MORNING, except Sunday, until further notice, and stopping at Petoskey and other principal points *en route*.

The SCENERY all along the line is WONDROUSLY BEAUTIFUL. —the AIR and WATER perfectly PURE—and on board, everything is provided for the COMFORT of passengers in the way of elegant furnishings, a table that is equalled by few hotels, and courteous attention from gentlemanly officers who are thorough sailors.

At TRAVERSE CITY is found the far-famed PARK-PLACE HOTEL, which, under the management of COL. BILLINGS (who continues in charge), has gained an enviable reputation.

Much of interest is to be enjoyed from this point, and the facts will warrant our saying that tourists always look back with pleasure to the time spent at

🟦 **PARK-PLACE HOTEL** 🟦

The same careful management of our steamboat and hotel interests which have made them so popular with the public will be continued, and we intend to fully deserve the large patronage which we confidently expect.

HANNAH, LAY & CO.,
Traverse City, Michigan.

Left: Steamships ushered in an age of luxury travel to Mackinac Island. *From The Annals of Fort Mackinac by Dwight H. Kelton.*

Below: After its time carrying passengers and freight to Mackinac Island ended, the *Peerless* served as a gambling boat off Chicago's Lake Michigan shoreline and later as a dredger in Muskegon, where it burned. *Library of Congress, det4a07885// hdl.loc.gov/loc.pnp/det.4a07885.*

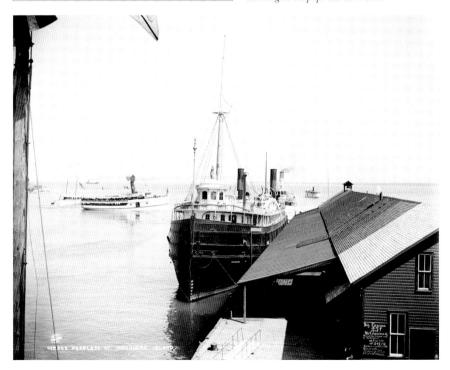

ticket price and prepared in a massive kitchen by a skilled staff that did not use microwave ovens, immersion blenders or automatic food processors.

Get a good night's rest aboard the steamer and wake up to a stick-to-your-ribs breakfast of stewed Santa Clara prunes, followed by calf's liver or broiled lamb chops and a steaming bowl of oatmeal.

When not gazing at the beautiful scenery as it passed by, passengers could enjoy a lively game of cards, play bingo or enter a shuffleboard tournament while listening to a live band. Railroad companies such as the Pennsylvania Road, owners of the steamer *Juniata* (rechristened the SS *Milwaukee Clipper*) were prohibited by the Panama Canal Act of 1912 from owning ships. This meant the end to the cooperative agreement of railroad companies and steamships that built Mackinac's tourism industry. The era of floating palaces lasted for nearly a century, ending due to waning interest and rising costs. Some floating palaces were sold for scrap or abandoned in lonesome shipyards.

LOST SHIPWRECKS

The Straits of Mackinac Shipwreck Preserve was established under the Michigan Natural Resources and Environment Protection Act of 1994 to provide access to shipwrecks in the Straits of Mackinac and to preserve 148 square miles, including the shoreline of Mackinac Island. Divers are urged by members of the preserve to exercise caution when visiting the sites. (More information on safely diving the sites is available on the web at www.straitspreserve.com.) There are fourteen shipwrecks in depths of up to 140 feet, shipwrecked from 1856 to 1965, and seven in shallow water, lost between 1850 and 1921.

Deepwater shipwrecks include the following. The *Sandusky*, a two-masted brig, sank in a gale on September 20, 1856. The *Dolphin*, a schooner, collided with the *Badger State* on July 6, 1869. The *Maitland*, a schooner, collided with the *Mears* on June 11, 1871. *St. Andrew*, a schooner, collided with the *Peshtigo* on June 26, 1878. The *M. Stalker*, a schooner, was struck by the *Muskoka* on November 5, 1886. The *Fred McBrier*, a steamship, collided with the *Progress* on October 3, 1890. The *William Young*, a schooner, sank on October 5, 1891. The *Minneapolis*, a steamship, was lost in a gale on April 4, 1894. The *William H. Barnum*, a steamship, was lost in icy water on April 3, 1894. The *Colonel Ellsworth*, a schooner, collided with the *Emily*

B. Maxwell on September 2, 1896. The *Northwest*, a schooner, was lost under submerged ice on April 6, 1898. The *Eber Ward*, a steamship, was torn open by ice on April 20, 1909. The *Elva*, a steamship, was deemed unfit for service and deliberately burned to celebrate construction of the Mackinac Bridge on May 16, 1954. The *Cedarville*, a steamer, collided with the *Topdalsfjord* on May 7, 1965.

Ships moored in shallow waters include the following. The *Henry Clay*, a two-masted brig, was stranded in shallow water on December 3, 1850. The *Genesee Chief*, a schooner, became waterlogged and was abandoned on August 24, 1891. The *Leviathan*, a steamship, burned on December 3, 1891. The *C.H. Johnson*, a schooner, was lost in a gale on September 23, 1895. The *L.B. Coates*, a schooner, was abandoned in August 1921. And the *Myrtie Ross*, a steamer, burned in 1894, was sunk in 1900 and deemed unfit for service on September 8, 1916.

LOST NATURE

An abundance of birds live on and visit Mackinac Island due to its varied terrain and location along major migratory routes. Anyone who has tried to enjoy a snack along the island's peaceful shoreline, only to have tranquility interrupted by hungry, begging birds—both ring-billed and herring gulls—knows about the birds of Mackinac Island, as do hikers on the island's interior trails, who carefully avoid stepping into piles of feces dropped by flocks of migrating Canada Geese—feces that may contain bacteria including *Chlamydia psittaci*, *E. coli*, *Listeria*, *Pasteurella multocida* and *Salmonella*. Depending on the season, Mackinac's bird population includes robins; four types of woodpeckers, the red-bellied, hairy, downy and pileated (the bird that looks like and laughs like Woody the Woodpecker); yellow and Blackburnian warblers, hopping on tree branches in search of yummy insects; red-tailed and Cooper's hawks; tree swallows and the more colorful barn swallows; blue jays; northern cardinals, which sing "pretty, pretty, pretty, birdie, birdie, birdie"; purple martins, which feast on many types of insects; bald eagles; Bohemian and cedar waxwings (so called because of the waxy substance they secrete from the tips of their wings); mallards, common goldeneyes; buffleheads; red-breasted mergansers; red-necked grebes; the almost-too-striking-to-be-real harlequin ducks and other water birds; and owls, chickadees and nuthatches.

Sadly, the passenger pigeon, once the most abundant bird on Mackinac, has been lost, hunted to extinction. In 1832, Thomas Nuttall wrote that

flocks of passenger pigeons blackened the sky for hours as they flew over the straits:

The approach of the mighty feathered army with a loud rushing roar, and a stirring breeze, attended by a sudden darkness, might be mistaken for a fearful tornado about to overwhelm the face of nature. For several hours together the vast host, extending some miles in breadth, still continues to pass in flocks without diminution…and they shut out the light as if it were an eclipse.

Imagine the harsh call of millions of birds, so loud they could be heard from miles away. Imagine flocks so large that the sky remained dark for hours as they flew across the straits. The passenger pigeon is not to be confused with the carrier pigeon (*Columba livia domestica*), a domesticated pigeon trained to carry messages. The scientific name, *Ectopistes migratorius*, indicates that passenger pigeons were migratory birds. Their common name is derived from the French word *passage*, which means passing by. These graceful birds bore some resemblance to mourning doves, though larger and with iridescent bronze feathers at the neck. Native Americans hunted passenger pigeons, as did Métis families who adopted the French custom of eating pigeons, as evidenced by bones found by the Mackinac Historic State Parks' archaeological digs. Abundant and cheap, the birds appeared on the menu of the Island House Hotel; barrels of salted pigeons were shipped to commercial establishments in Chicago and Detroit.

Not all passenger pigeons were hunted for food, however. Parties of enthusiast hunters used the live birds for target practice. On the command of "Pull!" a live passenger pigeon was released from a trap nearby and flew above a shooter. Clay discs, called clay pigeons, replaced the live birds after their extinction. On July 4, 1880, soldiers from Fort Mackinac competed against members of the Cheboygan Gun Club. Before the day was over, fifteen dozen birds had been killed. Hunters also affixed live passenger pigeons to perches called "stools." The bird's cries for help lured flocks down from the sky, toward the trapped bird, where hunters awaited with loaded rifles. After passenger pigeons went extinct, the term "stool pigeon" became slang for a human informer or spy sent into a group to report their activities to the police or government. The last passenger pigeons were observed on Mackinac Island in 1885, and by 1901, the species had gone extinct.

Nineteenth-century travel guidebooks recommended a tour of Mackinac Island's famous natural curiosities that had stood for centuries. Unfortunately,

due to natural erosion and human interference, two natural curiosities have been lost: Fairy Arch and Scott's Cave.

The beauty of Fairy Arch was first described by Fort Mackinac surgeon Dr. Francis LeBarron in 1802 as a natural arch of "Gothic Order" and dubbed "Fairy Arch" by surgeon Dr. John R. Bailey two decades later. In 1872, Constance Fenimore Cooper wrote, "Fairy Arch is of similar formation to Arched Rock, and lifts from the sands with a grace and beauty that justify the name bestowed upon it." The *Sandusky Register* considered it a must-see in 1889: "Of course the sight-seer [*sic*] to Mackinac must visit Fairy Arch, a beautiful arch formed by the rock one hundred feet above the lake and through whose almost perfect circle, the visitor sees the water and lake below." But reaching this natural curiosity proved difficult years earlier. In 1875, a Mackinac State Park guidebook cautioned, "[A] high pinnacle of rude rock crops out from the mountain side, near the base of which is a very picturesque arch, known as the 'Fairy Arch'….This spot is rather difficult of access owing to the presence of huge rocks and an entangled forest." To accommodate the growing tourism industry, a bit of nature was lost—boulders were pulled from the rugged path, underbrush was cut down and trees were felled for firewood.

The entrance to Scott's Cave was deceiving, the narrow opening through which visitors had to squeeze through belied the large cavern beyond. Less storied than Skull Cave, which hid human bones and provided refuge for Alexander Henry, Scott's Cave was nonetheless recommended as natural curiosity "where several people could stand erect" while listening to waves crashing outside, unaware that the lake was slowly eating the cave. *Town Crier* columnist Frank Straus reported that the high water levels were a source of erosion along Mackinac Island's shoreline and that water levels "have been monitored since the 1770s and carefully tracked since the 1820s."

Ultimately, human intervention destroyed these two natural curiosities. Scott's Cave and Fairy Arch were dynamited by the Mackinac Island State Park Commission after World War II to provide rock for road repair and shoreline riprap.

Trees and vegetation were also lost around the island due to construction. During the Great Depression, the State of Michigan announced a massive project to construct forty-five airports at the cost of $2 million; this included a small grass airstrip on Mackinac Island. Tall trees surrounding the original airfield made landing a plane hazardous, so they were removed. More trees were lost when a new landing strip was built early in the twenty-first century. Bulldozers chewed up earth and trees to make way for Reverend Humbard's

ill-fated ski slope. Old-growth trees were decimated by centuries of chopping wood for fires and building materials. Consequently, most trees grown prior to the nineteenth century no longer exist on Mackinac Island.

The development of farms resulted in the loss of trees as acres and acres of land were cleared for agricultural use. More recently, Mackinac Island farms were lost as the tourism industry evolved. For example, a farm owned by Simon Champaign lies beneath Stonecliffe and the Woods Golf Course. The Wawashkamo Golf Club and the Mackinac Community Equestrian Center were built on the site of the Dousman Farm, where Michael Dousman raised hay and supplied beef to for Fort Mackinac. During the War of 1812, as British and American troops fought in Dousman's fields, British troops dragged two six-pound cannons into position at the British Landing with the assistance of oxen they seized from Dousman's Farm. The Dousman and Early families continued to farm there until 1924, when the 640-acre farm was purchased by the State of Michigan. After British subject Dr. David Mitchell departed Mackinac Island in 1815, his wife continued to maintain a lucrative 110-acre farm lost to development of Harrisonville and the Grand Hotel Jewel Golf Course. While the Mitchell family occupied the land, they harvested much-needed hay. According to author Edwin Woods:

> *Hay was a very expensive article at Mackinac, at that time. It was customary for men to go to the surrounding islands, mow what grass they could among the bushes, remain there until the hay was cured, then return for boats to convey it to Mackinac.*

In addition to hay, Mrs. Mitchell grew oats, corn and potatoes. An attempt to grow fruit trees was unsuccessful on this side of the island and was abandoned. The white farmhouse, trimmed in green, featured a porch that ran across the front of the building, less impressive than Mitchell's home on Market Street, considered the largest home on the island at that time. Here she maintained a three-acre vegetable garden, enclosed by five-foot-high whitewashed cedar pickets, as was the style on Mackinac Island. Under her direction, Mrs. Mitchell's staff weeded the garden and deposited the weeds on the white beach, where they continued to thrive, creating a large mound of vegetation among the sand.

Mackinac Island farms grew potatoes that were prized around the country. In 1856, the *Buffalo Daily Republic* reported:

A beautiful quantity of Mackinac potatoes arrived this morning by the steamer Plymouth Roc. All who appreciate Mackinac potatoes will do well to purchase them. They are considered the finest potatoes in the world, and would make an Irishman go into raptures over them, either boiled, roast or fried—especially fried. If there is any esculent [edible] *that we are especially rabid about, it is the potato, and the find kind. They can be obtained only of C.L. SEYMOUR, Freight Agent, Michigan Central Railroad. Go and get a quantity of them at once or you will be too late.*

Ambrose Davenport sold his eighty-acre farm to wealthy businessman Gurdon Saltonstall Hubbard in 1855. In 1870, Hubbard built a small cottage that he dubbed "The Lilacs." One year later, Hubbard lost his Chicago home and business holdings in the Great Chicago Fire, including his insurance company, made bankrupt by payments to policy holders whose businesses were consumed by the fire. In an effort to recoup his fortune, Hubbard developed a community of fashionable summer cottages on the farm, and within five years, Hubbard's Annex to the National Park (now known simply as Hubbard's Annex) was born. Although the farm was lost, the cottage community proved to be a success.

BIBLIOGRAPHY

Books and Journals

Agassiz, Louis. *Lake Superior: Its Physical Character, Vegetation, and Animals Compared with Those of Other and Similar Regions*. Boston, MA: Gould, Kendall and Lincoln, 1850.

American Medical Association. *Journal of the American Medical Association* 23 (1894).

Appel, Livia, ed. *A Merry Briton in Pioneer Wisconsin*. Madison: Historical Society of Wisconsin, 1950.

Bailey, John R. *Mackinac Formerly Michilimackinac*. Lansing, MI: Robert Smith Printing Company, 1899.

Baird, Elizabeth Therese Fisher. *Reminiscences of Early Days on Mackinac Island*. Madison: State Historical Society of Wisconsin, 1898.

Beaven, James. *Recreations of a Long Vacation*. Toronto, CAN: Roswells and Thompson, 1846.

Blackbird, Andrew. *The History of the Ottawa and Chippewa Indians of Michigan: A Grammar of Their Language, and Personal and Family History of the Author*. Ypsilanti, MI: Ypsilanti Job Printing House, 1887.

Brisson, Steven C. *Downtown Mackinac Island: An Album of Historic Photos*. Mackinac Island, MI: Mackinac State Historic Parks, 2015.

Bundschuh, Scott. *Lightships: Keeping Watch Over the Great Lakes*. N.p.: independently published, 2020.

Choules, John O. *The Origin and History of Missions: A Record of the Voyages, Travels, Labors, and Successes of the Various Missionaries, Who Have Been Sent Forth by Protestant Societies and Churches to Evangelize the Heathen.* New York: Robert Carter, 1844.

Cochrane, Timothy, and Hawk Tolson. *A Good Boat Speaks for Itself.* Minneapolis: University of Minnesota Press, 2002.

Code of Ordinances of the City of Mackinac Island, Michigan. Available at city hall. Holmes Township and Village of Mackinac information available at www.cityofmi.org.

Corbusier, Fanny Dunbar. *Fanny Dunbar Corbusier: Recollections of Her Army Life, 1869–1908.* Edited by Patricia Y. Stallard. Norman: University of Oklahoma Press, 2003.

Dunnigan, Brian Leigh. *Fort Holmes.* Mackinac Island, MI: Mackinac Island State Park Commission, 1984.

———. *A Picturesque Situation: Mackinac Before Photography, 1615–1860.* Detroit, MI: Wayne State University Press, 2008.

Feltner, Dr. Charles E., and Jeri Baron. *Shipwrecks of the Straits of Mackinac.* Dearborn, MI: Seajay Publications, 1991.

Follin, James W. *Mackinac Island Typhoid Investigation.* Lansing: Michigan State Board of Health, 1915.

Foster, John Wilson. *Pilgrims of the Air: The Passing of the Passenger Pigeons.* London: Notting Hill Editions, 2017.

Galaway, Stephen. "Glenn Close Returns to Stage, Reveals Remarkable Childhood in Cult." *Hollywood Reporter*, August 15, 2014.

Gebhard, Elizabeth Louisa. *The Life and Ventures of the Original John Jacob Astor.* Hudson, NY: Bryan Printing Company, 1915.

Hallett, Christine. "The Attempt to Understand Puerperal Fever in the Eighteenth and Early Nineteenth Centuries: The Influence of Inflammation Theory." *Medical History* 49, no. 1 (January 1, 2006):1–28.

Hoyt, Susan Roark. *Lighthouses of Northwest Michigan.* Charleston, SC: Arcadia Publishing, 2004.

Humins, John Harold. "George Boyd: Indian Agent of the Upper Great Lakes, 1819–1842." Dissertation, Michigan State University, 1975.

Jaeschke, Brian S. *Where Shall They Be Sent?* Mackinac Island, MI: Mackinac Island State Park Commission, 2018.

Kelton, Dwight H. *Annals of Fort Mackinac.* Chicago: Fergus Printing Company, 1882.

Lyford, Carrie A. *The Crafts of the Ojibwa (Chippewa).* Washington, D.C.: U.S. Office of Indian Affairs, 1941.

MacKenzie, Morgan. "American Lightships, 1820–1983: History, Construction, and Archaeology within the Maritime Cultural Landscape." MA thesis, East Carolina University, 2011.

McKenney, Thomas L. *Sketches of a Tour to the Lakes*. Baltimore, MD: Fielding Lucas Junior, 1827.

Morgan, Ted. *Shovel of Stars: The Making of the American West, 1800 to the Present*. New York: Touchstone, 1995.

Morleigh. *A Merry Briton Lost in Frontier Wisconsin*. London: Saunders & Otley, 1842. Retrieved online, 2021.

Myer, Jesse S. *Life and Letters of Dr. William Beaumont*. St. Louis, MO: C.V. Mosby Company, 1912.

Newton, James. *Uncommon Friends: Life with Thomas Edison, Henry Ford, Harvey Firestone, Alexis Carrel, and Charles Lindbergh*. Boston: Mariner Books, 1989.

Nold, Carl R. *The Michigan Governor's Summer Residence*. Mackinac Island, MI: Mackinac State Historic Parks, 2013.

Nute, Grace Lee. *The Voyageur*. St. Paul: Minnesota Historical Society Press, 1987.

Porter, Mary Harriet. *Eliza Chappell: A Memoir*. Chicago: Fleming H. Revell, 1892.

Porter, Phil. *A Boy at Fort Mackinac: The Diary of Harold Dunbar Corbusier, 1883–1884, 1892*. Mackinac Island, MI: Mackinac State Historic Parks, 1994.

———. *A Desirable Station: Soldier Life at Fort Mackinac, 1867–1895*. Mackinac Island, MI: Mackinac State Historic Parks, 2003.

———. *Mackinac, an Island Famous in These Regions*. Mackinac Island, MI: Mackinac State Historic Parks, 1998.

———. *Mackinac Island's Post Cemetery*. Mackinac Island, MI: Mackinac State Historic Parks, 1999.

Public Health and Marine-Hospital Services of the United States. *Sewage Pollution of Interstate and International Waters*. N.p., 1912.

Schoolcraft, Henry Rowe. *Personal Memoirs of a Residence of Thirty Years with the Indian Tribes on the American Frontier*. Philadelphia, PA: Lippincott, Grambo and Company, 1851.

Sicherman, Barbara. *Alice Hamilton: A Life in Letters*. Urbana: University of Illinois Press, 2003.

Snider, Charles Henry Jeremiah. *In the Wake of the Eighteentwelvers; Fights & Flights of Frigates & Fore-'n'-Afters in the War of 1812–1815 on the Great Lakes*. New York: John Lane Company, 1913.

State Bar of Michigan. "The Pond and Maher Cases: Crime and Democracy on the Frontier." *Michigan Bar Journal* (December 2008).

Thwaites, Reuben Gold. *How George Rogers Clark Won the Northwest and Other Essays in Western History*. Chicago: A.C. McClurg & Company, 1903.

U.S. Bureau of Fisheries. *Report of the Commissioner for 1872–1873*. Washington, D.C.: Government Printing Office, 1874.

U.S. Congressional Record. August 10, 1961. www.govinfo.gov.

U.S. War Department. *Annual Report of the Surgeon General*. Washington, D.C.: U.S. Surgeon General's Office, 1883.

Van Fleet, Reverend J.A. *Old and New Mackinac with Copious Extracts from Marquette, Hennepin, La Houtan, Cadillac, Alexander Henry and Others*. Ann Arbor, MI: self-published, 1870.

Wendt, Edmund Charles. *A Treatise on Asiatic Cholera*. New York: William Wood and Company, 1885.

Western Journal of Medicine and Surgery. "The Northern Lakes: A Summer Resort for Invalids of the South" (December 1842).

Widder, Keith R. *Battle for the Soul: Metis Children Encounter Evangelical Protestants at Mackinac Mission, 1823–1837*. East Lansing: Michigan State University Press, 1999.

———. *Reports in Mackinac History and Archaeology, Number 4*. Mackinac Island, MI: Mackinac State Historic Parks, 1975.

Williams, Elizabeth Whitney. *A Child of the Sea; and Life Among the Mormons*. N.p.: Elizabeth Whitney Williams, 1905.

Williams, Meade. *Early Mackinac: An Historical and Descriptive Sketch*. 4th ed. St. Louis, MO: Buschart Bros. Print, 1903.

———. *Early Mackinac: The Fairy Island, a Sketch*. 2nd ed. St. Louis, MO: Buschart Bros. Print, 1898.

Wilson, Craig. *The Changing Face of Fort Mackinac*. Mackinac Island, MI: Mackinac State Historic Parks, 2016.

Wood, Edwin O. *Historic Mackinac: The Historical, Picturesque and Legendary Features of the Mackinac Country*. Vol. 2. New York: Macmillan Company, 1918.

Wright, Larry, and Patricia Wright. *Lightships of the Great Lakes*. Severn, CAN, 2011.

Newspaper Archives

Akron Beacon Journal
Arizona Republic
Ashtabula Weekly Telegraph

Barre Daily Times
Battle Creek Enquirer
Buffalo Courier

Buffalo Daily Republic
Buffalo Democracy
Buffalo Enquirer
Daily Oklahoman
Democratic Free Press
Detroit Free Press
Evening News
Evening Times
Herald Palladium
Idaho Free Press
Inter-Ocean

Lansing Journal
Lansing State Journal
New York Times
Petoskey News
Record
Red Deer Advocate
San Francisco Examiner
Somerset Press
South Bend Tribune
Town Crier

ABOUT THE AUTHOR

Kelly Pucci enjoys historical research. She holds a master's degree in education and a master's degree in library science. She is the author of five books: *The Information Brokers: How to Start and Operate Your Own Fee-Based Service*, *Stranded at O'Hare*, *Camp Douglas: Chicago's Civil War Prison*, *Chicago's First Crime King: Michael Cassius McDonald* and *The Hidden History of St. Joseph County, Michigan*, as well as magazine articles on subjects ranging from urban beekeeping to the history of picture postcards.